D1418496

MOMMA LOVE

MOMMA LOVE

How the Mother Half Lives

text and photographs by ALI SMITH

Dear Juliette + Scott
To two people who "fight the
good fight" + live with passion!
Sending you much Love.
♥ Ali 5/13

THUNDER
B·A·B·Y
press

FOR HARPER

FOREWORD BY JOAN BLADES

Momma Love offers remarkable visions and stories of motherhood at a time when being a mother ain't what it used to be. As you'll see as you experience these varied families, the melding of new and old expectations gives rise to both brilliant, shining moments and impossible challenges. Ali Smith captures these dynamics—and more—amazingly well in her striking photographs, which leap off the page with all of the immediacy of life in progress.

Thirty years ago, I flourished, full of hope and optimism, as I enjoyed the freedom that the women's movement had begun to create. Twenty years ago, I had my son and fell in love in a way I had never imagined possible. Seven years ago, I became aware that the great promise of feminism had fallen far short of what I'd hoped for during the movement's "second wave."

There remains a deep bias against mothers in hiring, wages, and advancement. A woman without children makes about ninety cents to an equally qualified man's dollar, while a mother makes seventy-three cents and a single mother only about sixty. No wonder there are so many women and children living in poverty! No wonder there are only twelve women CEOs in the Fortune 500! Yes, women have made progress—but the bias against mothers in the workplace is undeniable and profound.

What does modern motherhood look like, and what could be different about this picture? How can we make it possible for mothers and families to thrive in a culture in which more than half of college graduates are women and a majority of mothers work? It's time to envision a society in which we celebrate work and family—and the delicate balance between the two—by enabling parents to meet their responsibilities in both spheres. Viewing the images collected here, and reading all of the rich stories behind them, I'm reminded of both the challenges and remarkable opportunities we face. This book is the celebration and the call-to-arms that today's "mommas" so richly deserve.

Award-winning writer and organizer JOAN BLADES is the co-founder of MOVEON.ORG and MOMSRISING.ORG. She is also a co-creator of LIVINGROOMCONVERSATIONS.ORG, small structured conversations that empower citizens with different perspectives to build understanding and relationships. She is the co-author, with Nanette Fondas, of *The Custom-Fit Workplace: Choose When Where and How to Work and Boost Your Bottom Line,* and, with Kristin Rowe-Finkbeiner of *The Motherhood Manifesto.* Joan is a software entrepreneur, nature lover, former attorney/mediator, artist, mother, and true believer in the power of individual citizens to change the world. ✧

"DOMESTIC BLISS,"

a celebrity magazine article swoons as it describes visiting with a famous couple at home after the recent birth of their twins. "Sheer perfection. I'm happier than I've ever been," the mother, an international superstar, is quoted as saying. Her face in the accompanying photo is disturbingly placid and wrinkle-free.

At forty years old, she coos, "It was an easy birth." She's thin as a pin just one month after the experience. In an era when wealthy women are notoriously arranging for cesareans followed by tummy tuck surgeries to avoid the unseemly, telltale signs of childbirth, I suspect she's had help looking this way. She boasts that it was easy getting pregnant. "It was fun! We tried all the time." Still, the fertility industry is built on the dollars of wealthy women over the age of thirty-five, many of whom end up with multiples. Maybe her pregnancy wasn't as effortless as she makes it seem? She makes many allusions to changing diapers, three a.m. feedings, and getting no sleep and loving it! But it seems likely that hired help has a role to play in the way she effortlessly meets these challenges. Accompanying her blissful rant are images of her and hubby literally skipping down their driveway, pushing identical oversized baby prams—the kind that aren't exactly built for getting up and down subway steps or in and out of cabs. The caption pointedly notes that each pram costs "in excess of $3,000."

The picture of motherhood this celebrity mom is helping to sustain is a damaging one to the psyches of women who face the real challenges of motherhood every day. Women reading this overly simplistic nonsense are bound to feel they're doing something wrong if their lives aren't all soft edges and quiet moments of rapture. Additionally, if their children aren't shaking pewter rattles from Tiffany, there's an insinuation that they might be getting shortchanged.

At the other end of the spectrum, a local rag runs a story about a five-year-old girl killed by her stepfather. He's been convicted of delivering the final blow that ultimately crushed her tiny body, but it's revealed that both the mother and he had been using her as a punching bag for years. I shake my head and wonder, yet again, why people don't need a license to have a child.

In the gap between these extremes are millions of women who try their best every single day, under ordinary (though varied) circumstances, to make motherhood work. These are mothers who work to keep their children healthy—and themselves sane—in the face of varying levels of support that they receive from partners, employers, lawmakers, and popular culture.

Momma Love is not only about the love a mother shows. It's about the love she is shown, by herself and the world around her.

We all feel an undeniable pull toward our mother's love. If the

bond between you and your mother was strong and healthy, it created a space of unparalleled safety and comfort for you. If it was distorted, or missing entirely, you've probably spent a lifetime coming to terms with that fact, seeking it out or letting it go. Either way, "momma love" is profoundly symbolic and powerful—so much so that entire religions, mythologies, and classic works of literature are built around either the sanctity or the destructive power of it. Societies need momma love in order to survive, but they often don't know how to take care of it properly. The details and rituals of motherhood go largely unnoticed and get taken for granted. They are talked about among mothers in private places: in toy-strewn living rooms, in kitchens, or over the phone while a child throws a tantrum on the floor nearby.

When I began this project, I was an outsider. Motherhood seemed like a profoundly important secret society that I wanted to understand more fully before I signed up to join. Each woman who appears in these pages has the truth of her experience to offer. In creating this book I have attempted to bring a community to light and create a quilt of advice, empathy, reflection, commiseration, opinion, anger, assurance, and love. I became a mother six years into the project. What I'd hoped would happen, has come to pass. The stories, wisdom, and anecdotal evidence shared with me by these women have helped shape who I am as a mother. Each day, a turn of phrase or an insight from one of them pops into my brain when I most need it, and I often find guidance, or at least comfort, in the commonality of our experiences. As a result, I'm a kinder, more patient (both with my child and with myself), more satisfied mother, one who still falls short on a daily basis, but who has some perspective on that fact. And when I collapse in heaving sobs over the constraints of my newfound role or the guilt I feel when I think I've failed my son, I know I'm not alone.

In order to nurture healthier mothers and a healthier society, honest conversations—about the realities of motherhood and how mothers are treated—are necessary. In taking their portraits and in talking with them, I asked my subjects to be as open, personal, and candid as they could be. I knew that every mother who picked up *Momma Love* would have her bullshit detector set on high. I didn't want to relegate my subjects to the sentimentalized, soft-focus arena in which mothers with children are most often depicted. I wanted to open the curtains and let the noise, the dirt, the color, the energy, the highs and lows, the best and the worst of motherhood come through. Thankfully, my attempts to steer the photos away from more typical portraits of women smiling and hugging their children were met with great enthusiasm on the part of both the mothers and the children. I took this as a sign of their desire to acknowledge and maybe even honor the complexity of their relationships.

Often, after an interview was done, the subject came to me nervously, concerned that in the process of revealing her ambivalence, struggles, or conflicts regarding motherhood she hadn't made it clear how much she adored her children. All I could tell her was what I believe, in no uncertain terms: that admitting to the complexity of the situation doesn't negate the love. On the contrary, if you're committed to someone in spite of the inherent difficulties, it might just be evidence of a more powerful kind of love.

My first book, *Laws of the Bandit Queens*, celebrated renegade women who have been an inspiration in my life, and, more specifically, in my career. This book depicts the realm where life as a Bandit Queen meets motherhood. It still reveres an enthusiastic, vibrant, longing spirit in women, but it shows the ways in which that spirit is inevitably altered—sometimes frustratingly diminished, sometimes gloriously enhanced—by entering the secret motherhood society. Also revealed in these pages is the transformation that's occurred from the way our own mothers experienced motherhood to the realities of being a mother today. *Momma Love* strives to illuminate the differences between one generation and another, as well as the startling similarities.

In 1950s America, the figure of "mother" came to represent a handful of things, all revolving around an image of serene perfection and selfless subjugation. In response to the inevitable wave of dissatisfaction that this brought to many women, the image of a dissatisfied, pill-popping mom—immortalized in the Rolling Stones song, "Mother's Little Helper"—became a common maternal mythology during the '60s. By the '70s, with the women's movement shaking things up in the home and the workplace, some older women who'd already had kids started to notice the gulf between the opportunities they'd had and the ones available to younger women, including their daughters (who, in many cases, were opting out of motherhood entirely, seeing it as a constraint that had shackled their own mothers). This often became a source of great frustration for them. Some felt they'd been ripped off, and this manifested itself in all manner of spiky ways.

During this era, the traditional family unit, which frequently hid a multitude of flaws and sins behind a veneer of perfection, started to crumble. Inevitably, a lot of children's needs got lost in the shuffle as the family rearranged itself. But what was emerging, and continues to evolve, may have been something as simple as a more honest, more attainable idea of family and motherhood. The process of debunking the myth of the "perfect" family—complete with a "perfect," traditional mother at its helm—was an uncomfortable one, sporadic and spotty. There's no one doctrine that all mothers adhere to and there's no one common "oppressor" they can all agree is responsible for the challenges and frustrations they face, or the fact that they still often face them largely on their own.

In the '80s, more women began to postpone marriage and family in favor of careers. It was this rat-race career track that Diane Keaton's character opted out of in the film *Baby Boom*. Backlashes begat backlashes. Remember "mommy wars," a media-fueled mania that pitted stay-at-home mothers against working ones, rather than focusing on societal issues that affect them both? And ever since mothers have attempted to combine parenting with a career, there has been "mommy tracking," in which a woman's career path is adversely affected by the mere fact of her motherhood. Evidence of that one, sadly, can still be found—even among the women profiled here.

It's said that mainstream entertainment reflects movements in a culture. In the '90s we saw *Roseanne*, in which a far-from-perfect moth-

er seemed to propose that love and commitment trump perfection in raising kids. More recently, in *Baby Mama*, Tina Fey and Amy Poehler mined the comedy in a common contemporary scenario in which career-track women explore the unconventional road to motherhood via surrogate.

But just as our culture begins to acknowledge and even celebrate the less-than-perfect-but-still-good mother figure, it tempers that acceptance in numerous ways. In the more frivolous but still impactful vein, as I waited in line today to buy cheddar bunnies for my son, I was confronted with this headline: "BEST AND WORST MOMS!" This magazine had devised an actual grading system! Angelina Jolie, by the way, received a critical C-, while America's sweetheart, Sandra Bullock, received an A-. Next to a photo of new mom Jessica Simpson screamed the headline "SHE CAN'T LOSE A POUND!" If this, too, is a reflection of popular culture's opinion of mothers, our society is rather merciless towards them. We're literally grading mothers now, it seems, and snapping a photo every time they trip while carrying their child. Which, by the way, I did not so long ago. (Thank goodness there were no cameras.)

On the more serious side of popular thought, there are currently great swaths of society that resist sex education for girls and women—thereby robbing them of the vital information they need in order to make informed choices about their reproductive lives. The struggle goes on, with no end in sight, between those who feel that women should have dominion over their lives and bodies, and those who would like to impose serious limits on that idea. The conversation about differences in mothers and mothering is in the public sphere, but nowhere in society do people, en masse, feel more entitled and eager to give their opinion.

I decided when I was young—not consciously but through osmosis—that I wanted to experience the same entitlement, adventure, and independence more often cultivated in boys and encouraged in men. Thankfully, this aspiration was tacitly fostered by both of my parents. Instead of just dating a musician, I would be the one in the band. I would travel. I would have a career. I would experience a variety of lovers. In other words, I would go for what I wanted. I'm grateful I grew up with my eyes and mind open in that way, but I think that maybe in trying to stick to that agenda, I inadvertently ignored some of the softer, perhaps more stereotypically feminine things about my nature, which I'm now learning to make room for.

It took me by surprise to discover firsthand that the biological clock is a real thing, and that once it has begun to tick-tick-tick, it does so with great intensity. In my mid-thirties, I suddenly experienced the most incredible emotional and physical yearning for a child. I can't say to what degree those feelings were due to social conditioning or biology, but I can confirm that I felt them deeply and powerfully. For some women, these feelings must seem like the most natural ones in the world. But for many of us, the idea of motherhood conflicts sharply with lives already in progress, threatening to force us to give up many hard-won prizes. We fear it even while we want it. The longer we wait to have kids (and, because of lifestyle choices and medical advances, many women are waiting longer these days), the more likely we are to have already established our lives and our sense of individuality; the more likely we are to consider what we will lose alongside what we will

gain. But then this vision materializes of a person who sees us as an incomparable source of love, someone who will in some ways always be an extension of us, someone who (everyone seems to promise) will change our lives for the better.

The decision to have a child, when it is a decision, inevitably starts out as a somewhat selfish one—"What do I want, what's best for my life?"—but it then requires selflessness to be done well. I hoped to find myself able and happy to make that transition successfully, but I certainly wasn't sure that I would. My mother had often seemed depressed and distracted in the role. I'd seen that same scenario in plenty of my childhood friends' households. Was that par for the course—become a mom and commit yourself to a life of mild dissatisfaction and emotional depletion? That was my paramount fear.

My friend Mary calls the care of a child "the most primordial burden and blessing." It's the place where the primal and socialized animals in us meet most dramatically. Women who live, as I do, in an industrialized country, face the moral conflicts brought on by our relative privilege and wealth of choices. I find myself confronting the same fears I know many women feel, fears that we may never admit to anyone: Will my relationship suffer? Will my sex life change? Will my friends be bored with me? Will my employers look at me differently? Will my work suffer? If I decide not to work, will I, in fact, be a traitor to my gender, helping to negate years of struggle that afforded me the opportunity to make that decision for myself? Figuring out whether to keep working (if one has the luxury of making that choice), how to continue to pursue personal goals, how to manage the ins and outs of daily life—in short, how to embrace family life while maintaining a sense of self—still falls disproportionately more to women than to men.

One of the subjects in this book, Amy Richards, considers her partnership with her husband to be pretty equal in regard to childcare, but she also makes more money than he does, so by traditional standards, she feels he should probably be taking on more of the childcare. Erika DeVries and Wendy Kagan have both been pleased to find their partners willing to share equally in childcare duties, but they are certainly the exceptions that prove the rule. The idea that the non-familial activities of men's lives are somehow more critical and vital to their well-being and to society still lingers. The talents, aspirations, and personal goals of women still tend to be treated as more easily and necessarily expendable in exchange for the duties of motherhood.

I drag my child to all manner of activities—from story hour to Spanish song classes—and I'm still stunned by the fact that it's almost exclusively mothers, nannies, and grannies that show up. If a father makes an appearance, I find myself inanely grinning at him, as if he's evidence of a swing toward all fathers being more involved with their children. Never mind that there is just one of him, surrounded by thirty women. I experience conflicting emotions. As for the nannies (who, in New York City at least, are disproportionately non-Caucasian), I wonder who is watching their babies. But I also feel...proud. Proud to be a part of a group of nurturers who I imagine to be, in a fundamental way, kind-hearted. Truth be told, there are pockets of progressive parenting out there that include very committed fathers, and that is good news.

The subject of work-home balance is now at least a part of public discourse. Concepts such as flexible work hours and paid family leave are being explored and negotiated by lawmakers. But in real-world

terms, achieving this balance is still elusive for most. Alicia Mikles hoped to continue working at a job she'd become very good at over the course of twelve years. She just wanted to blend the new reality of her motherhood into the mix. In the end, the two were incompatible for her. While, at least in theory, society holds child-rearing in high esteem, it does little to support working mothers or reinforce the idea of joint parental responsibility. Laws are enacted to make sure men "pay for their children," but there are many messages transmitted every day that let them off the hook when it comes to the nuts and bolts of raising them.

The reality today is that, for various reasons, in most households both parents do some sort of work outside of the home. Nevertheless, after the mother, the father is often not the next in line to care for the children. The responsibility often falls to hired he lp. The fact that many women can't afford childcare, never mind great childcare (and who really wants to accept bargain-basement quality when it comes to the care of their children?), creates its own set of problems. When we begin to rely on outside help to raise our family, everything must go exactly right. If anything goes wrong in that equation—if a child is harmed by someone charged with caring for it—often the mother, besides being devastated, is blamed.

While the family shifts and realigns, and women and men reexamine their roles as parents, children continue to need what they've always needed: love, support, and security. The definition of what constitutes a family is more flexible than it used to be, but the parenting contract still requires sacrifice and dedication. And no matter how a woman handles motherhood, there will inevitably come judgment—from the world around her as well as from within—because of the enormous symbolic weight of the term mother.

No one woman's story here sums up the entirety of her experience or feelings; that wasn't my goal. But it does reflect a real piece of it, and an aspect that mothers are not often encouraged to speak out about or examine. Women's lives are composed of an array of factors that all affect the momma love they are able to give. From the healthiest mothers spring the healthiest societies. Each mother presents—to her child, to the world at large, to herself—a myriad of sometimes conflicting messages, failed ideals, the genuine beauty of self-sacrifice, and the potential for the most profound manifestation of love.

Completing *Momma Love: How the Mother Half Lives* has been an all-consuming, soul-satisfying, decade-long journey that has changed my life. I've met amazing women and have learned a tremendous amount from them about life, motherhood and myself. They have bared their souls and shared great intimacies with me.

Some of these stories will resonate with you. Others will piss you off. That is inevitable, and is as it should be. But what I believe may emerge is the commonality in the experience of living life as a mother rather than the differences in the details. And I'm confident that in one or in many stories, you will find a reflection of your own experience. I hope you will find strength in these shared truths. ✧

MOMMA LOVE ISN'T ONLY ABOUT THE LOVE A MOTHER SHOWS.

IT'S ABOUT THE LOVE SHE IS SHOWN, BY HERSELF AND THE WORLD AROUND HER.

MICHELE QUAN IN BED THE OTHER NIGHT, A FLASH IN MY HEAD

We were hiking upstate at North Lake, where the big rock cliffs over-look the Hudson Valley, and Elsie Tree ran right off the edge. It was so fast and there was nothing I could do except run off after her.

Once it played in my head, I couldn't get it out and I couldn't make anything else happen. My friend said it's "the shift"—when all of a sudden there's somebody else in your life who you really can't live without. Elsie's loss would just be the end, and I would die. That's when I knew everything was forever changed.

The half hour before bath time can be such heaven. I turn on Chet Baker and undress her, let her roll around on the bed all naked. She rolls onto her side and pulls my hair, touches my face, smiles at me, talks to me. Her body looks so little and scrumptious when she's naked, and I cup her bum cheeks in my hand. She laughs when I kiss her tummy and surprise her. This little person is unfolding right before my very eyes.

I remember parents always saying that raising a child is hard, but that they love their children to death and couldn't imagine life without them. In some ways there is no more me. But in another way, I'm finding out more about me through her.

I ask myself daily, how can I love this little person so much? It feels limitless, bottomless, it just stretches on into eternity. I see pic-tures of mothers and their babies from a hundred years ago, and I see the same love in their faces.

Momma Love. ✧

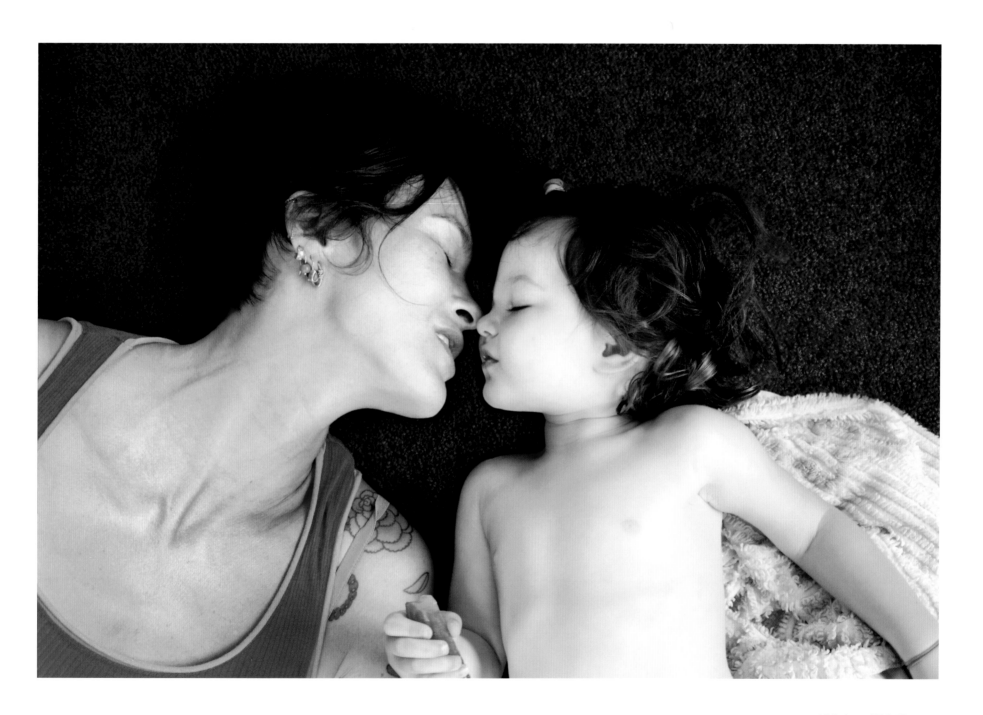

Michele and Elsie Kiss

Elsie Cries

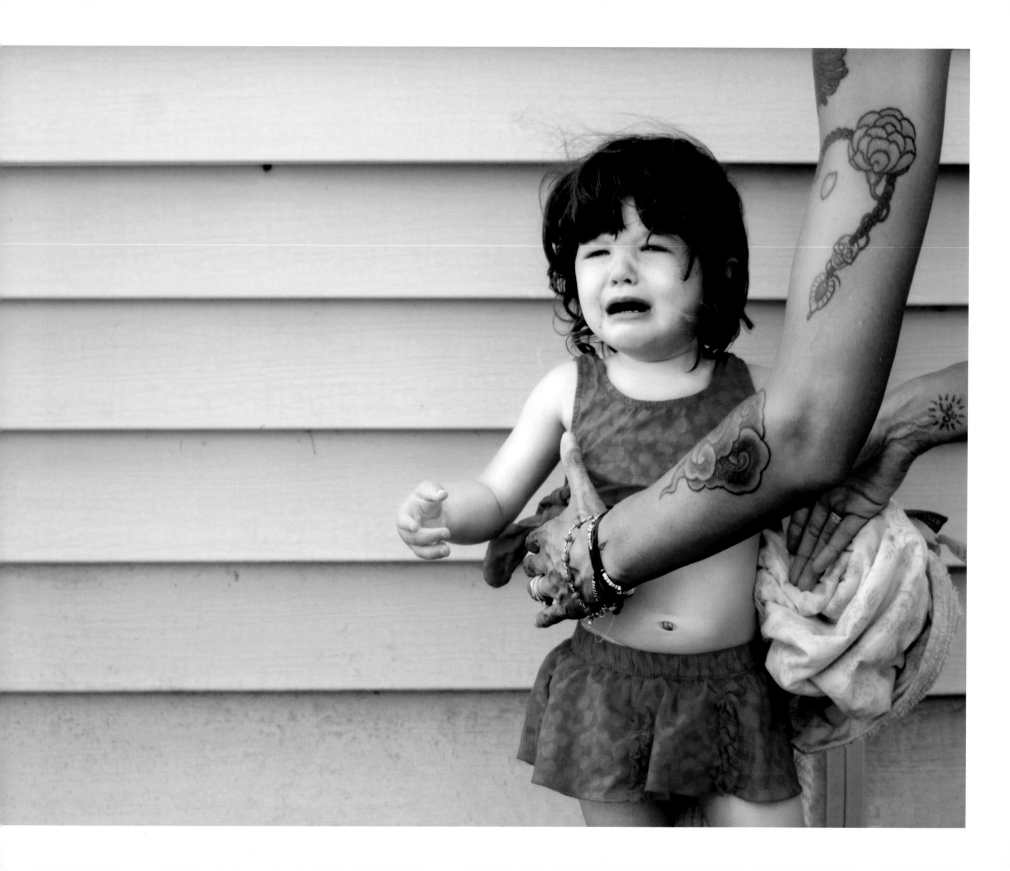

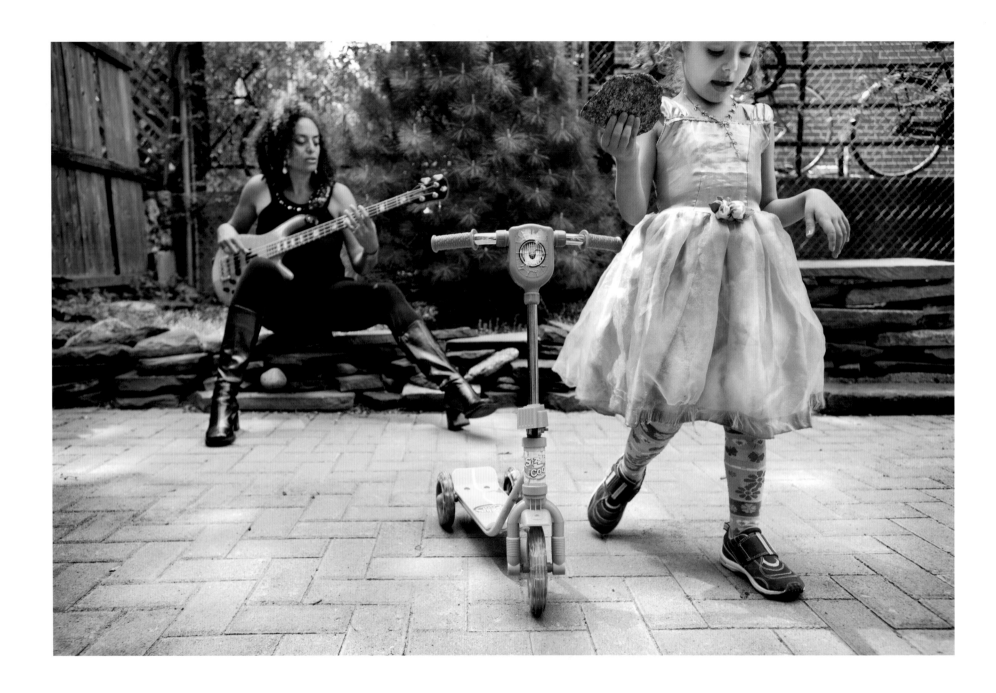

Alyson and Ruby in the Backyard

ALYSON PALMER ALL CONTRACTS FOR MY BAND BETTY NOW HAVE "EXPERIENCED, RELIABLE BABYSITTERS WITH REFERENCES" WRITTEN INTO THE RIDER, WHERE ONCE WE HAD LISTED A DOZEN DIFFERENT KINDS OF COCKTAILS.

So at showtime, I know my two kidlets are cared for. My husband, Tony, and I bring along a backpack that's just books, crayons, toys, Etch A Sketch, and dolls for four-year-old Ruby and one-year-old Lake for the green room, hotel, or plane. Both kids have been on well over a hundred flights, so they're cool with traveling.

As for the compatibility of raising kids with my lifestyle, I simply didn't think much about it ahead of time. I suppose because it was like peering into the abyss. I am not a "kid person" and had absolutely no idea what lay ahead. I guessed that rockmamahood would be equivalent to taking care of a special-needs cat. Ignorance is bliss. But something changed in me after 9/11. I went to the desert and sat alone under the stars and asked myself, in stillness, "If your life ended tomorrow, what would you regret?" And I realized that the only thing in the entire world that was important was love. To manifest the most of it I could, I would create a child with my partner of eighteen years, Tony, a man made almost entirely of love.

Having been the star of my own life for so many years, how absolutely challenging it was to become a bit player in my own movie; at times only an extra! Luckily, my doula also specializes in postpartum care for new mothers. She was an unceasing source of comfort and reality while my hormones surged and my sense of self shattered into a million pieces. As I've slowly come to appreciate the person beneath that outer shell, my goals have changed. I'm not better or worse than I was before, just different...richer in an alternative way, tired in every other way.

The more conscious I become of this new sense of self, the more delightful it is. I am more conscious of the energy I'm putting into the world from the stage. BETTY has always embraced life and love, been fiercely feminist and uncompromising. I add to that now a respect for the gentle in life, the innocent and the tender.

In a traditional pairing, if the male feels as though he's fairly doing half the work of childcare and shouldering half the responsibility,

he's doing about a quarter of what he should. Actual measuring begins upon conception, when the woman physically commits to creating an entire human being inside her body for almost a whole year. Add to that the months and years she spends breastfeeding; the hormonal changes; the loss of muscle tone, dewy youth, and physical identity; the new fears, vulnerability, and exhaustion.

An ongoing topic with my postpartum doula/therapist has been my panic about messing up the kids' psyches somehow. I don't fear the traveling around. I call that "roadschooling." I grew up moving every two years, so I'm drawn to new environments and new experiences, as long as we have what I didn't have: a secure home base. My fear is that I'm too hard on them or too doting, that I'm loving too hard or not enough. My own childhood was so full of anxiety that I have no blueprint for how to have a healthy, happy family. I would gnaw off my bass-fretting hand before I whipped them like my father strapped my brother and me at the slightest provocation. My doula pointed out, "Then there is your blueprint." Could it really be that simple? Every time my children act up or push my buttons and I choose an action that is decisive but loving, I strike back at my father's insane rage, my mother's broken withdrawal. I am raising my children and healing something in myself at the same time.

What I am compelled to put into the world is richer now that these two new lives have intertwined with mine and Tony's. My voice is less strident, more mellow. I am more confident about the sum of my ability, even though I never dreamed my ass would be so big. My compassion is vast for all women. ✦

ANY MAN WHO SAYS INDIGNANTLY, "HEY! I WATCHED THE KIDS

FOR THREE WEEKS WHILE YOU WERE RECORDING" CAN BLOW ME.

HANNAH BRIGHT THERE ARE VARIOUS ASPECTS TO THE
IDEA OF "WANTING YOUR BODY BACK" AFTER BIRTH.

There's the wanting to get back to your original shape and fitness. But there are other bits to the "wanting your body back" question, too. First, you're aware throughout pregnancy of this weird thing growing inside you. Not just growing inside you and feeding off you, but actually controlling your body. The placenta takes over your hormones and makes your body behave in certain ways, producing more blood, making your heart, liver, kidneys, and digestion work much better, shrinking your brain, making you breathless or exhausted for no reason, and generally making you lose control.

In the case of the health profession, they poke and prod and stitch and cut, and from the word go you are just an object, your body just a machine that they have to make sure is working in the right way. Then, of course, if you have a hospital birth, you are entirely in their hands. Using a birthing pool was my attempt to regain a bit of control by creating a private, watery space that others, including my partner and the midwife, could only reach into, but that was really mine.

Other people control you, too. You suddenly become public property. Complete strangers feel that they can comment on your shape and condition, saying things like, "Oh, it must be a girl, you're carrying the weight all over." Or, "How many months are you? You're huge!" No one would dream of commenting on the body shape or size of a complete stranger if she weren't pregnant. It's like you lose control and privacy about your own body.

So although it would be nice to "get my body back," perhaps what I was really afraid of was that I would not get my life back. That's one of the compromises you make when entering motherhood. It's an old cliché, but the rewards make it worth it. The problem is that there are so many words you can use to express the challenges—exhaustion, loss of control, time management, lack of support, career compromises—but there really aren't words that adequately express the joys. So you find that when you're talking about the experience, it feels like a somewhat lopsided conversation. I just know that I've had more laughs—more genuine, joyful belly laughs—since Lizzie's been born than I'd had in the previous thirty-six years of my life. ✦

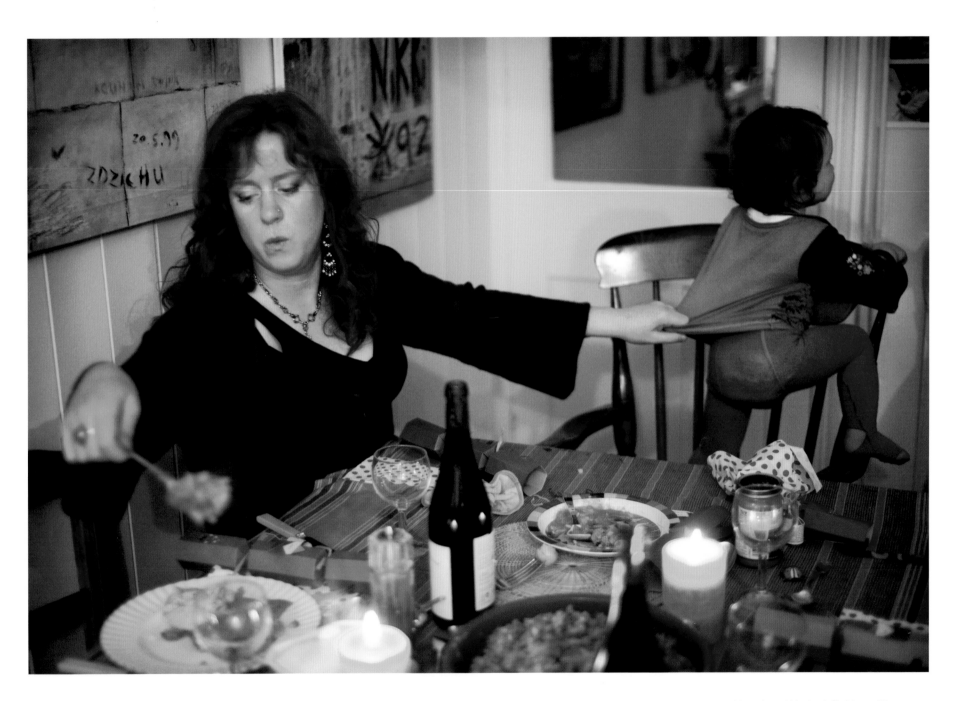

Hannah and Lizzie at Christmas Dinner

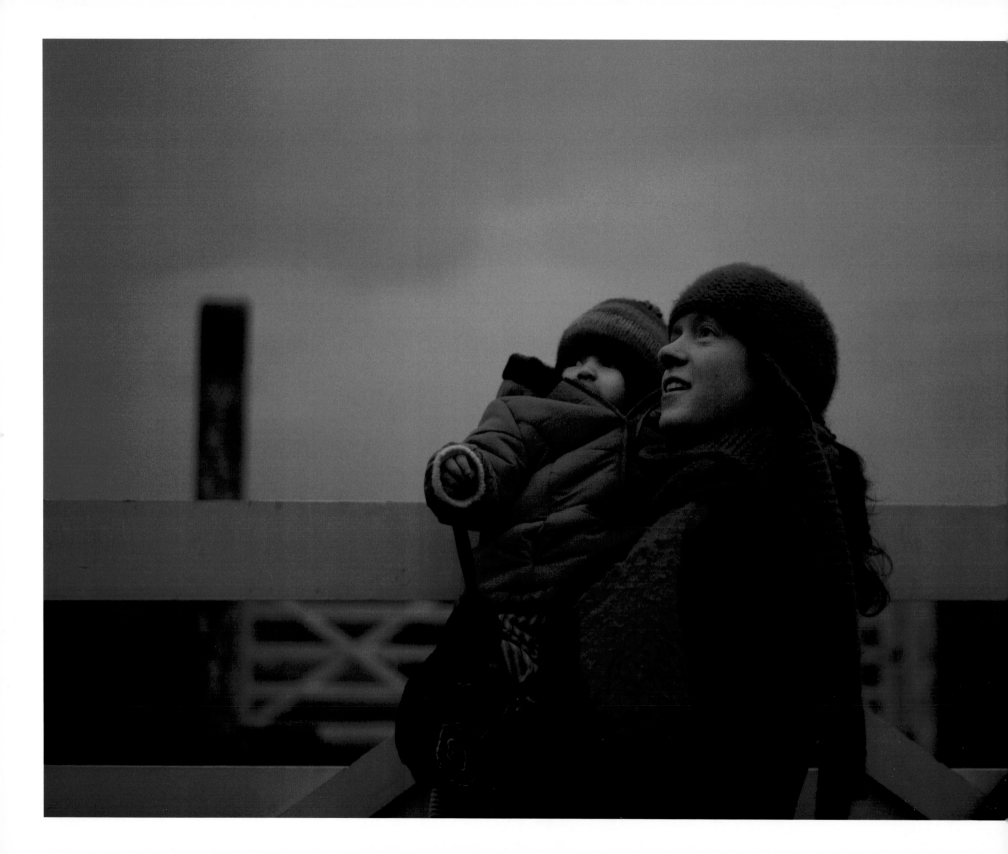

YOU HAVE TO LEARN TO LET GO OF CONTROL OF YOUR BODY, WHICH I THINK MIGHT BE PART OF THE PROCESS OF PREPARATION FOR MOTHERHOOD.

Hannah and Lizzie Watch the Rooks

KITTY STILLUFSEN BY THE AGE OF THIRTY-FIVE, I HAD HAD ENOUGH LIFE EXPERIENCE TO KNOW THAT WHILE I DID WANT A CHILD, I DID NOT WANT TO COMPROMISE OR SETTLE WHEN IT CAME TO A "BABY DADDY."

I certainly didn't want one who was not wholeheartedly ready for parenthood. Choosing a father for your baby is one of the most important decisions a woman can make. So what started as a funny "What if?" conversation with Darren, my best friend of twenty years, became a "Should we?" conversation.

Darren and I were always on the same page. We share the same sense of humor, the same sense of right and wrong, and the same parenting philosophies, and our families have been dear friends for two decades. The only thing preventing Darren from being my perfect boyfriend is that he is a gay man who already has the perfect boyfriend, Sam.

I didn't choose Darren and Sam because they were my only choice. I chose them because they were my best choice!

We are fortunate enough to live in a society where family planning is an option, and this is all about family planning. Darren, Sam, and I talked about having this baby for over a year. We talked about the pros and cons, custody, navigating of potential difficulties—we talked about all of that before there was any problem. Most couples end up discussing these things only when there is a problem.

We laugh about what a better place the world would be if everyone took this much time to discuss how they would raise their child before they had one.

I believe that the foundation of a family is love, support, and positivity. That is the environment I am determined to raise our daughter in. I have no fear of judgment from others. Plus the responses I've gotten from people have been really positive for the most part. As for explaining our situation to Olive someday, I will tell her that I chose two wonderful daddies for her and that she's a very lucky girl. If it's all she knows, it will be familiar to her. I believe it's the quality of her family that will count. ✧

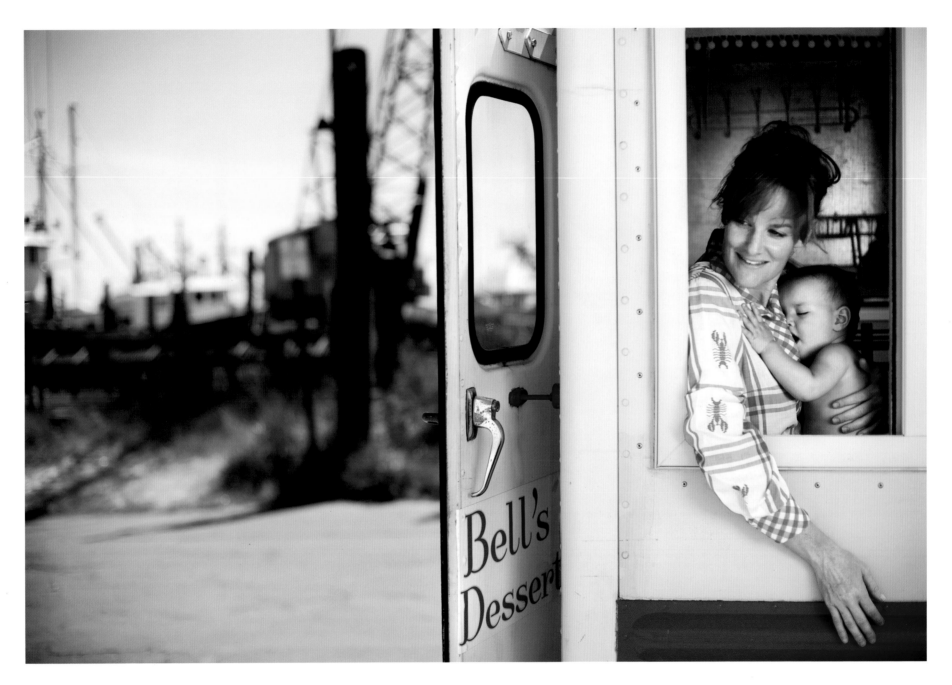

Kitty and Olive in the Dessert Truck

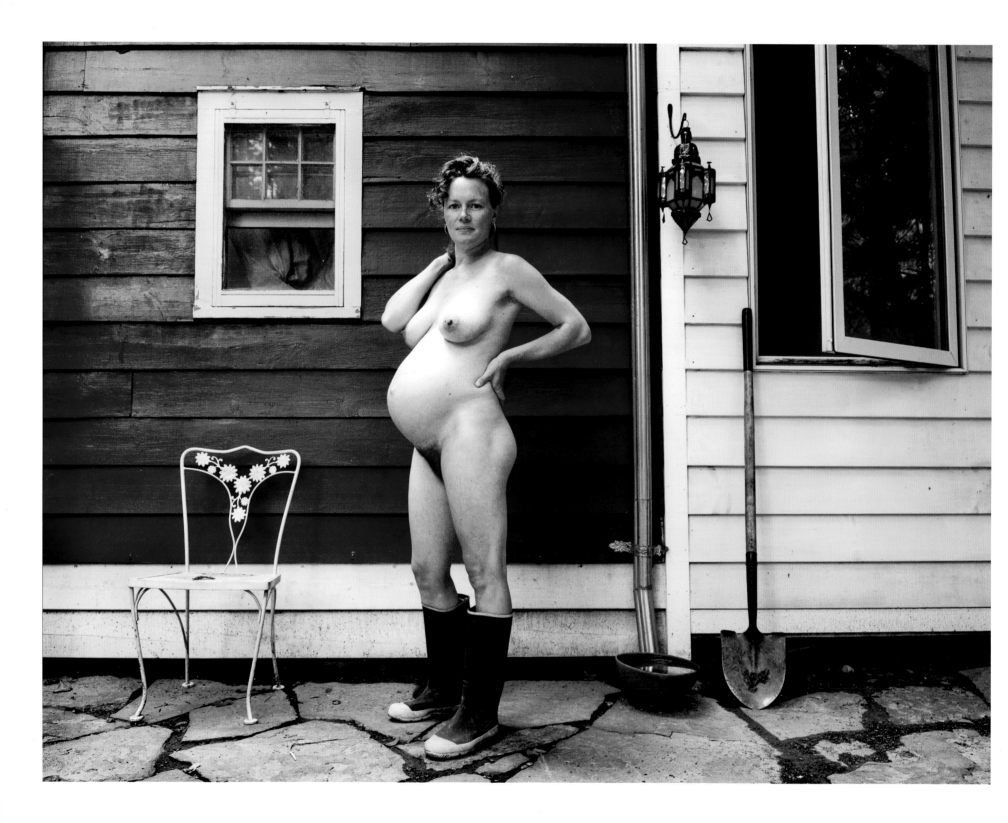

KELLY STORRS A COUPLE OF WEEKS AFTER THE BIRTH OF MY SON, MY HUSBAND AND I WENT TO A FRIEND'S HOUSE FOR DINNER.

This woman had been really involved in our lives since the baby was born. Sometimes I felt she was too involved. She inundated us with information, even more so than my mother or my husband's mother did.

So we went over to her place for a dinner party while I was experiencing the total exhaustion of a new mother who's not getting any sleep. People looked at me sideways and I'd start crying. Despite the conflicted feelings I was having towards her, my friend and I had a great time until after the meal, sitting in the living room, when I had to change Angus's diaper. The only place to change him was on a table in the middle of the room, in front of everybody. He was exposed to everyone and it quickly became obvious that he isn't circumcised. Suddenly, the whole conversation turned to circumcision and this friend became very opinionated about the subject. She told me that if she'd had a boy, she definitely would have had him circumcised. Soon everyone was chiming in with an opinion—and adamantly, since no one but me was sober. The consensus seemed to be that this boy should be circumcised. And there was Angus in the middle, so vulnerable, with his little penis exposed.

My husband left the room, annoyed with the conversation. Then Angus started getting agitated, maybe picking up on the energy of the people around him, and this friend started saying, "I know what that baby needs. He needs to eat." She wouldn't stop saying it, over and over, until I just grabbed my son and stormed out of the house crying.

The next day it dawned on me. For whatever reason, this woman had been undermining me for quite awhile. This incident made me realize that it really is all about defining your relationship with your baby in those first days and weeks, and that nobody else can do that for you. It's also about you defining yourself as a mother.

For the rest of his life and for the rest of my life, as long as we're both alive on this earth together, I'm going to have to stand up for him and stand up for myself with whatever I think is best. So many things aren't entirely clear, not black and white. We have to be clear about what we believe in and what we're willing to risk or not risk. There's nobody who can take that power away. I needed to take that power for myself, and what happened was really an amazing lesson that gave me my wings. ✧

Kelly Pregnant Outside

AMY RYAN I THINK, CHILD OR NO CHILD, HOLLYWOOD KNOWS I AM OF "MOM AGE,"
AND AS AN ACTOR, I'VE BEEN IN THE MOM CATEGORY FOR SOME TIME NOW.

It emphasizes the continued importance of choosing roles wisely. But I also believe I would do that if I weren't a mom in real life.

When I first had Georgia, my publicist and agent recommended I stay away from talking too much about motherhood in any interviews. At first I was offended, but later I realized they were only protecting me from some uglier side of the world that they know about. I did actively decide I wouldn't hide this monumental event in my life, though, and did talk about Georgia in the press when asked—but only as much as I would share with any stranger. I didn't feel the need to share her birth story or poop habits, but there was no way I wouldn't acknowledge her arrival.

I was conscious, during my first post-baby job, of trying not to voice how tired I was from parenting a newborn. So I suppose I am fearful in some regard of being thought of as not "up to the task" or having my "plate too full." I hope to be the only person to ever feel that way about me.

During a recent break on the set of a television show I'm currently filming, my costar asked me what good books I'd read lately. This is an actor I've really admired for awhile and an adrenaline rush ran through my body as I scrambled to think of an answer, even though I knew I hadn't read a single one since Georgia was born a year earlier. I tried to think of something I may have read in the past that would make me sound interesting, intellectual. Then a feeling washed over me. I wasn't gonna hide who I am now. It doesn't matter what anyone thinks. Plus they're just making conversation, not testing me. So I just admitted that I hadn't read any books during the previous year since I'd had my baby. I opened up that vulnerable part of myself that might be seen as not interesting enough or important enough, and it ended up being so much easier than trying to pretend that my life hadn't changed. My honesty immediately brought that person back to fifteen years earlier when he was a new parent. A smile came over his face and he said, "Ah, of course! I remember not having time to read either." As a result, an instant and real bond was formed and I got to proudly wear the skin of my new self. ✧

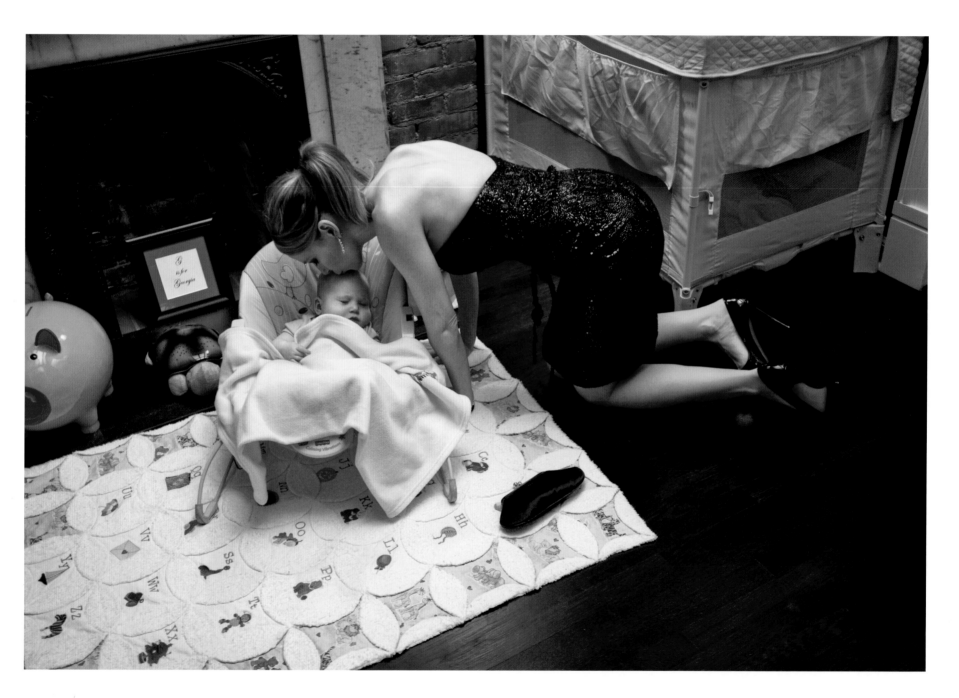

Amy Kisses Georgia Before a Film Premiere

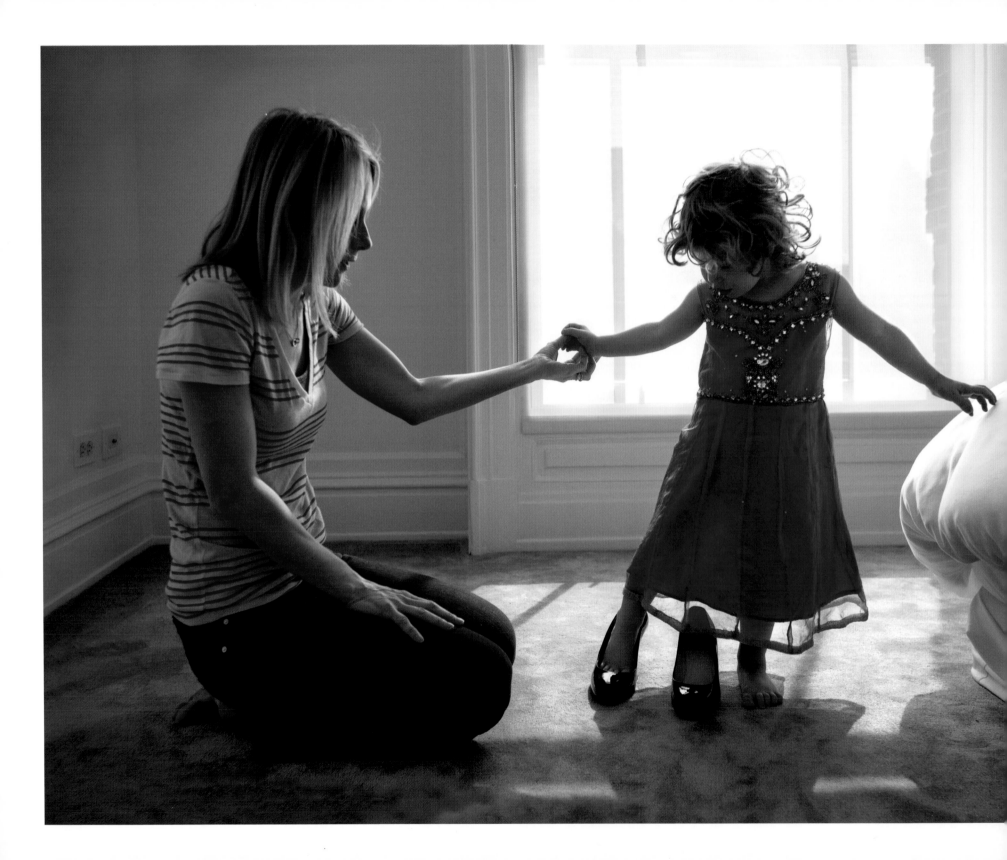

MOTHERHOOD IS THE BEST PUBLIC/PRIVATE SECRET IN THE WORLD. IT IS A CONTINUING LESSON IN PATIENCE AND CURIOSITY. AND IN THE PUREST SENSE OF THE WORD: LOVE. UNTAINTED. UNSELFISH. JUST PURE.

Georgia in Black Heels

BROOKE WILLIAMS BOTH DIAGNOSES CHANGED MY LIFE.

We got married when I was thirty-six and I really wanted a year of just having a relationship before we started to try having kids. At the end of that first year, just at the time we'd said we'd start trying, I was diagnosed with MS, an autoimmune disorder that affects the central nervous system. It often hits women of childbearing age, in their late twenties to their forties, and its impact can range from mild to debilitating.

Because I was finally with this amazing man who'd make a great father, I became determined, after the initial shock wore off, not to let MS get in the way of us starting a family. I figured if we had to get extra help or change our lives around to make it work, we would.

It took about a year after the diagnosis to readjust to life, and then it took six months or so till we got pregnant. It was only then that I started to worry. Everyone else was getting excited and buying baby stuff, but I remained wary, always aware of the possibility of problems, maybe because I was a little bit older, maybe because I'd already been blindsided once, by my own disease. At eighteen weeks, the amnio came back showing a diagnosis of Down syndrome. We had addressed it as a possibility, talked about it a ton, the whole time we were waiting for the test results, and we knew that should this happen, we were going to terminate the pregnancy. We were both really on board with that, but it was still one of the most difficult, saddest things I have ever done.

The decision to terminate came out of our strong belief that the world is a really, really difficult place to live in, even when a person has many advantages. We didn't want to knowingly bring someone into the world who would be at the disadvantage both of their own disorder and of an older mother with a disease that might cause her to someday not be able to properly care for them. When you have a child, you hope you can give them the best care you possibly can, for as long as you can. If my symptoms were to become severe and my energy and emotional resources depleted in the future, would I be able to properly care for a child who would inevitably need lifelong assistance? This is the reason that we have these tests; to make informed decisions about our children's futures. It's one of the first major choices you have to make as a parent.

It took about six months before we started ardently trying to get pregnant again, and then it was over a year before I got pregnant. I definitely kept myself safe emotionally again. The first time, I thought maybe I was overly cautious to do so, but now it made sense. We'd been through something major and I was acutely aware of the things that can go wrong.

At eleven weeks I decided to have a CVS, which is a test for Down syndrome and other genetic disorders that can be done earlier than an amnio. I remember so clearly when they called to tell me that everything was okay. I got off the phone with the hospital and I started crying uncontrollably. For months, I'd been working so hard not to freak out—to stay calm. Once I was able to just let myself go, all of the emo-

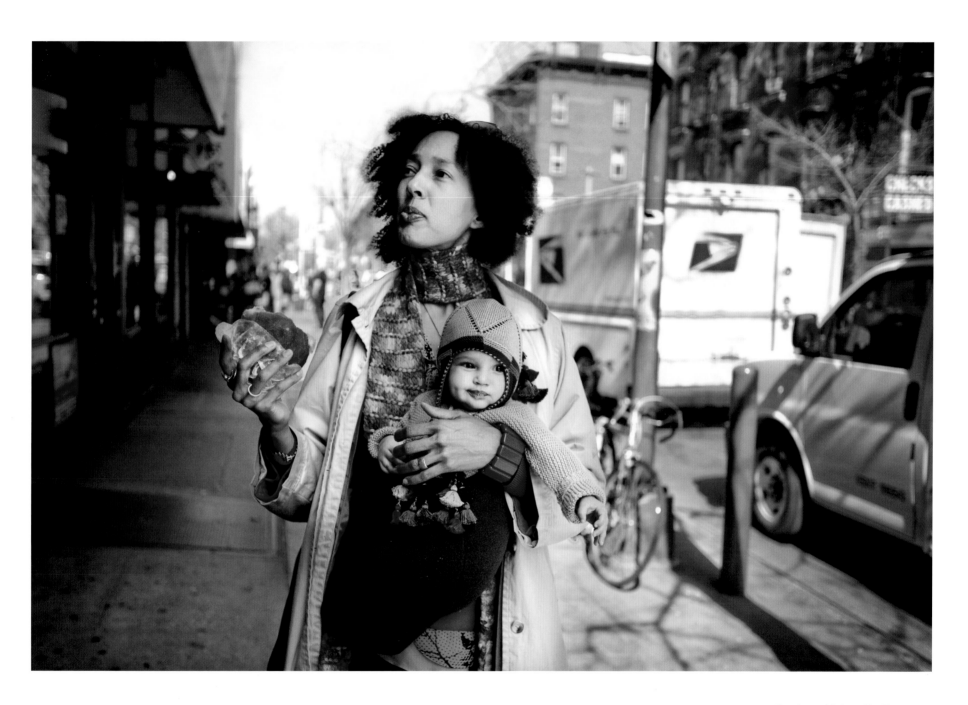

Brooke and Ada on the Street

tions—the hope, the joy I'd had but kept inside through two pregnancies—came pouring out.

I pulled myself together long enough to make the call to my husband's office, but when I heard his voice, I burst into tears again. It eventually dawned on me that he thought I was calling with bad news. So through my sobbing I managed to say, "It's a girl and she's okay!" I remember it vividly. It felt amazing.

Finding out about Down syndrome and going through a termination is not something that I would choose to do over again. But having gone through that experience has definitely informed how my husband and I felt once we finally had our child. Because the road was a little longer and harder, and we've gone through such a struggle, I am all the more certain about how much I want to be Ada's mother.

Three years into motherhood, every day has been an incredible gift. ✧

Ada's Third Birthday

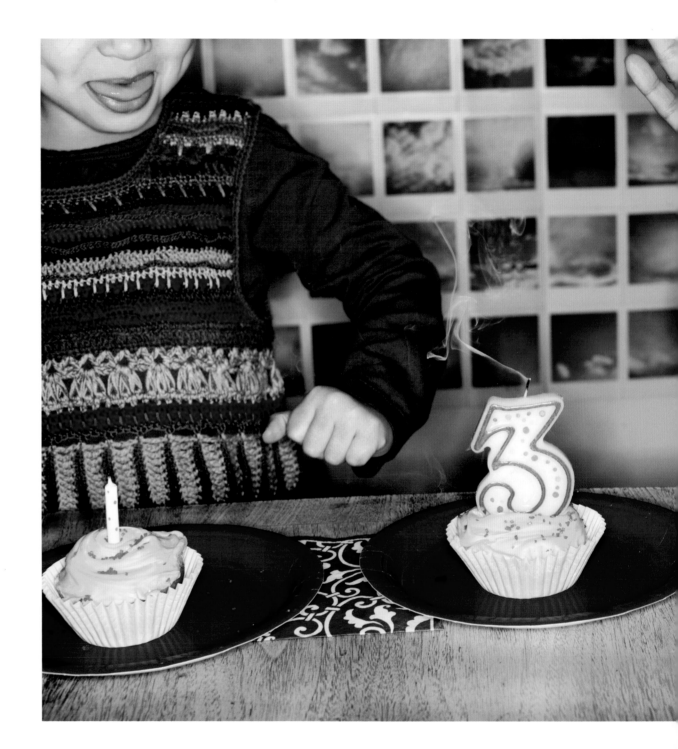

BRENDA DAVIS ISABELLE'S FATHER AND I BROKE UP WHEN SHE WAS VERY YOUNG. AFTER THAT, HE WAS VERY CASUALLY IN AND OUT OF HER LIFE, WHICH WAS REALLY HARD FOR HER.

He'd show up unreliably and then leave saying noncommittal things like, "See ya later, kiddo!" He eventually started a relationship with a woman who was very jealous, and that led to his being even more absent and unreliable.

There was a period after the breakup when I moved to LA from New York City and basically hunkered down into motherhood, making homemade baby food, taking long walks on the beach with Isabelle, diapering, teething, very organic living, while grieving the loss of a relationship I'd assumed would last. There was a two-month period where I would get a babysitter and go to a bar in Hollywood and drink beer, dance, and kick up my kick-ass boots. And when moved to, I would smash beer bottles into the corner of the cement floor or into a garbage can...a release, some sort of harmless exorcism. Then I'd get up in the morning, make organic baby food, and nap when Isabelle napped.

When she was eleven, she sent her father what amounted to a letter of divorce. It said, basically, "You're lame and I never want to see you again." His response, predictably, was a noncommittal "It's me, not you" letter.

At first I was freaked out about how the choices adults make affect their children. But what Isabelle did was a really empowering act and I told her I thought she was incredibly brave. I said that whatever she felt about her father was okay and that she was going to feel a lot of things about him, from that moment until she was a very old woman. Even if she decided she wanted to see him again, it would be okay.

Through a lot of work, frustration, tears, and meditation, I no longer have any pangs of sadness or anger for myself. Do I wish Isabelle's father were in her life? Two loving parents would be the best-case scenario. Do I want her pushing a big rock her whole life that, in the end, will not move? No, I don't want that to be her fate. So if she felt a responsibility to herself to write that letter stating that she is not willing to accept only ten percent of a man's love, I can't think of that as sad. Yes, it affects her. No one who has been abandoned by a parent is unaffected by it. But she decided to protect her own psyche.

The positive take on the letter is that she will never accept morsels and fragments of a relationship from anyone. ✧

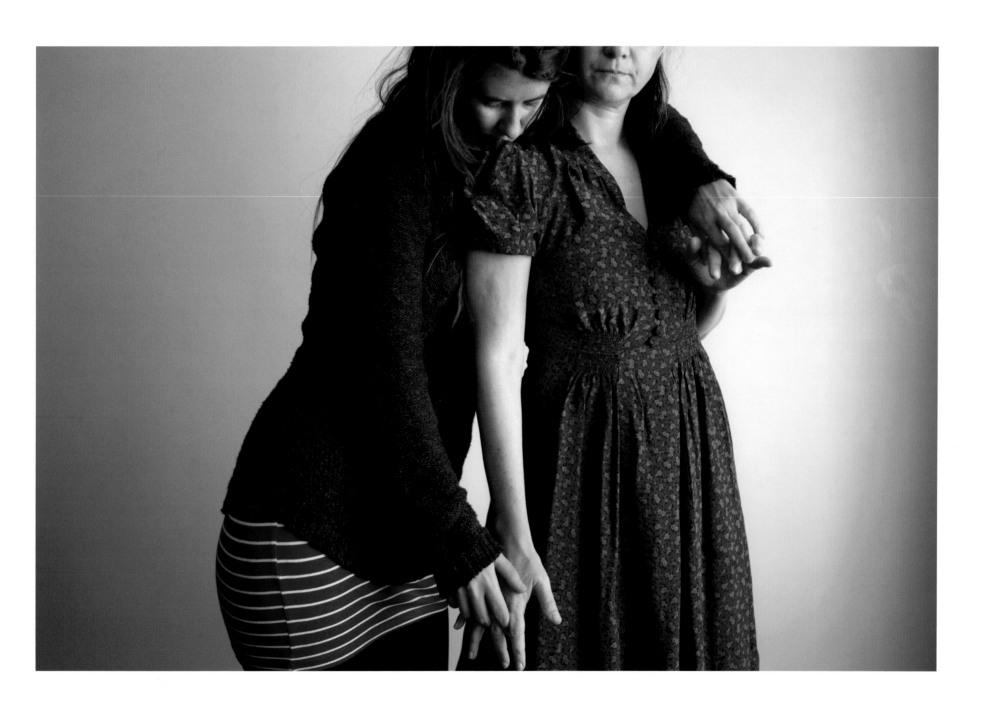

Brenda and Isabelle at Home

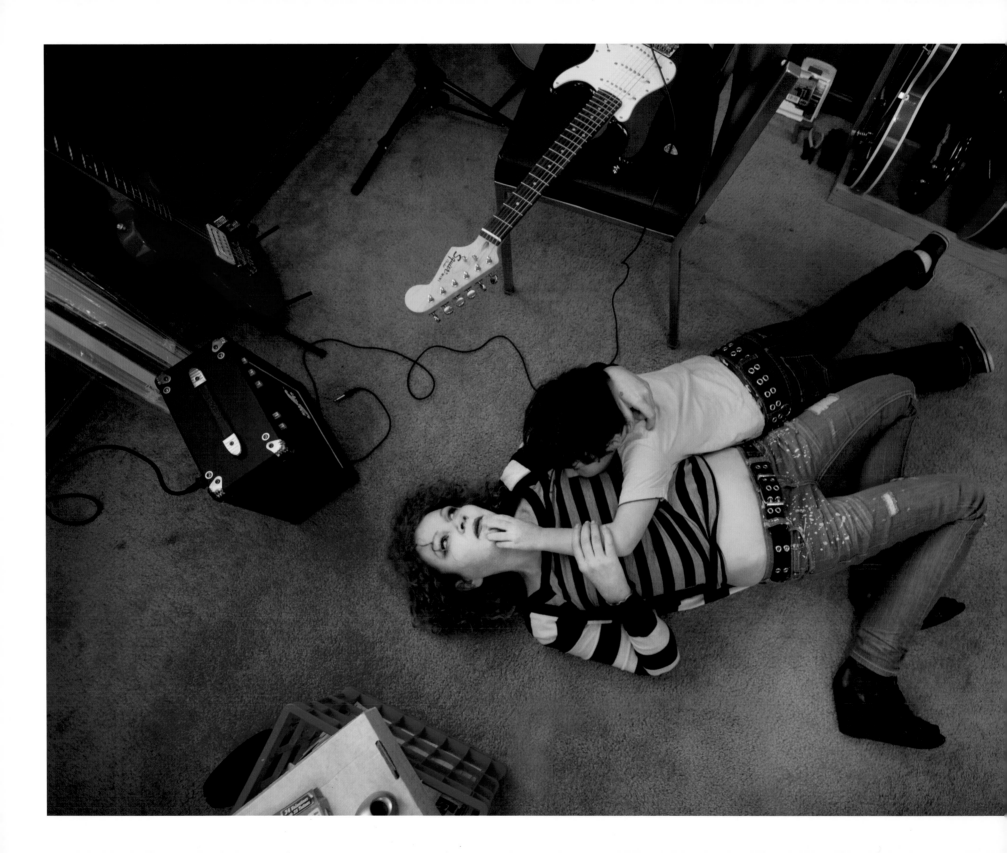

MELANIE WADSWORTH I WAS A HAPPY AND LOVED CHILD UNTIL ABOUT FIVE YEARS OLD WHEN MY MOTHER MET A MAN WHO STARTED SEXUALLY ABUSING ME AND CONTINUED TO DO SO FOR SEVEN YEARS.

Whenever he was around, my days were full of fear and unhappiness. I retreated into a solitary world to cope with the pain, and my whole life has been filled with one type of coping mechanism or another, whether it be drinking, drugging, abusing myself by starvation, or just shutting myself off from any kind of love so that I could protect myself from getting hurt.

At the age of forty, after dating a man for about four years on and off, I discovered I was pregnant, which I'd thought would be impossible because I hadn't menstruated in months due to the abuse I'd put my body through. So I didn't really choose to have a family, it kind of chose me. It's been challenging.

In the beginning, I was incredibly fearful of my son being traumatized by any little thing I did wrong, so I always strove to be the perfect mother, which doesn't exist. Eventually, giving up all my energy to him and not taking very good care of myself, emotionally or mentally, overwhelmed me and I had a nervous breakdown when he was three.

Lionel has seen me go through a lot and he has obviously been seriously affected by it, which fills me with guilt and remorse. I don't have much control over what I may hand down to him genetically. I worry about it because my biological father was alcoholic and manic-depressive and I've struggled with addiction. But I can only try to control the environment in which he grows up, and hope that if he does have a mental illness or addiction that he has his own higher power that will be able to help him.

In my heart, we are inseparable. My job is to give him any wisdom and truth that I have to offer. And to love him and let go of my desire to get love back from him, although I know he does love me. I had a needy mom who wanted to be my best friend and it prevented her from guiding me and protecting me when I was being harmed. She was a lonely woman who got her self-worth from her career and her lover. Those things took priority over me and my siblings. By freeing Lionel from my needs, but hopefully always being there for him when he needs me, I am breaking the cycle.

My illness and addictions are separate from my love for my child. I'm working hard on becoming healthier so I can become the mother he needs me to be. I can't force change, but I do believe I'm on the road to putting the instinctual, motherly part of me in balance with the abused child who could not think clearly about the best way to be a mom. ✧

Melanie and Lionel on the Floor

I DO THINK THAT NO MATTER WHAT YOUR MOTHER IS LIKE, IF YOU FEEL LOVE FROM HER, THAT COUNTS FOR A LOT. HE KNOWS I LOVE HIM UNCONDITIONALLY, EVEN THOUGH THAT'S SOMETHING I HAVEN'T BEEN ABLE TO DO FOR MYSELF.

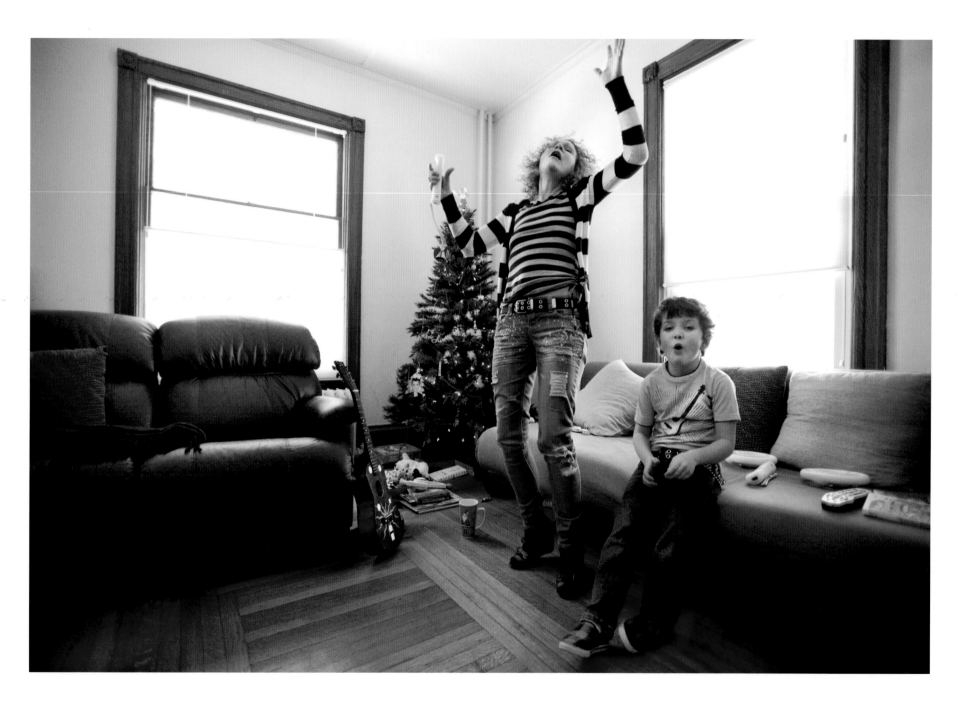

Melanie and Lionel Play Video Games

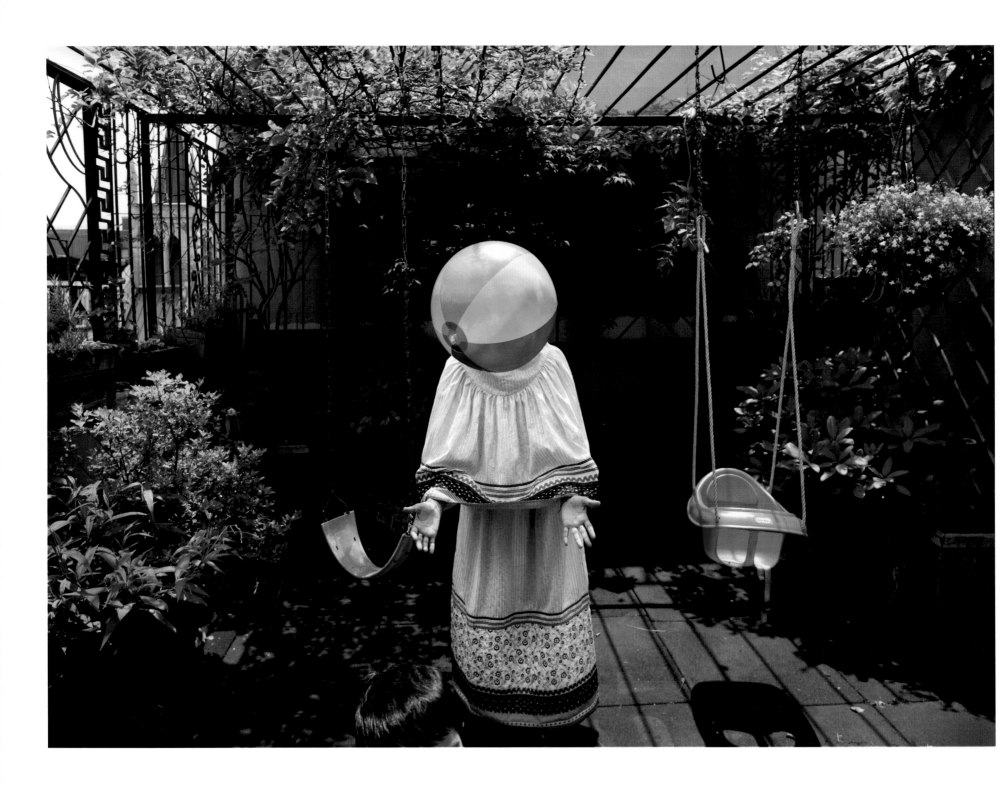

RASHIDA TAHERALY IF I COULD OPEN MY HEART AND LET ALL THE CONTENTS POUR OUT ONTO THE PAGE, IT WOULD SAY

that my journey of motherhood has been so moving that if I had not had children, my life as a woman would surely have been incomplete. I would not have been even half a person.

I am a loving, powerful, and courageous woman and mom. I am thirty-four years old and have a wonderful husband, Mukaram, two gorgeous daughters, and a beautiful baby boy.

I was married into a very respectful, loving Gujarati Muslim home. We live traditionally in New York City (which is practically unheard of in this day and age, especially in Manhattan). My father-in-law had a vision for his two sons and was a stickler in some ways. Being born and brought up in Manchester, England, I experienced some of the Indian religious traditions but lost many connections to my roots along the way, including my language. I am proud that I've learned to make space for myself in this more traditional family, as it has completed me and tied me to my roots.

We all live together in one building: my brother-in-law, sister-in-law, and their children live in the second-floor apartment; my mother-in-law and father-in-law are in the third-floor apartment; and my husband and I live on the top floor with our three children. Between the family business we run together and our Indian traditions, our lives are completely intertwined.

When my first baby girl was born, we all rejoiced. But, as is common in many eastern cultures, the family wanted a boy—a successor to carry on the lineage and all that. It was unsaid, but upon Lamiya's birth, I sensed it immediately:

"Maybe the next one will be a son!"

"This is only their first child."

"Look at your sister-in-law. She had a girl first and then a son! There is still time!"

Regardless, I was happy with my precious "Snowdrop", as I called her, and we enjoyed her thoroughly.

A year passed and I started to feel the indirect pressure of my in-laws. They loved us and wanted what's best, and today I realize that it was more about the gravity I personally gave their pressure at the time—but still, it was real to me.

The expectations began to be verbalized: "Your husband needs a boy!" We went to the holy priest for his blessing and asked for boy talismans.

I conceived again and readied myself for what God would give us while all around me, people commented openly about their hopes for a boy. Never did I truly realize how these comments and expectations were affecting me.

When Khadija was born, we were all happy to have her, but the pressure I felt to deliver a boy increased tenfold. I hated myself for feeling this way and did not let it cause me to turn away from my two little girls; I

gave my love and attention fully to them. They are both the most loveable, joyful little girls ever.

My in-laws resumed coaching me:

"Start now, try again!"

"Time is precious."

"We must get special prayers for a boy!"

I'd tell them that a girl is just as precious and powerful—even our religious scriptures state this. But I felt all eyes were on me to produce a boy.

Without planning to, I conceived again. As my pregnancy went on, I knew it was another girl. I felt just as I had during the other pregnancies. I warned my in-laws that this was the case. I didn't want a repeat of the last two births, where the whole world was excited and waiting for something to pop. And then when it didn't go as they'd hoped, it was their expectations that popped!

We went to a religious event in Colombo, Sri Lanka, and ten days into the event, I suffered a miscarriage. Even though we say every thing happens for a reason, the loss was tragic. I knew I needed to take care of my body and release myself from the pressures around me.

Time went on, and as pressure for a boy increased, conceiving became more difficult. It was becoming unbearable! I explored all options: Internet fads, alkaline foods, even a book that promised "Dr. Shettle's method of gender selection."

The last coaching call I had with my father-in law was very impactful. He said to me, "Rashida, you know why I want you to have a boy so badly? Not for Mukaram or Mama or myself, but for you! He will be there if, God forbid, anything happens to Mukaram! And we are here today but not tomorrow. Our lives are almost complete!" When he left me that day, I broke down and sobbed.

Questions rushed into me. Why could I not perform as others did? What was wrong with me? Once I'd exhausted myself thinking about all of this, I focused. I would do what I could to conceive a boy, but whatever God gave me would be my gift and my treasure, boy or girl.

My husband Mukaram was at the same turning point. Whatever we got would be perfect and would be our last child. We would not keep trying until we got a boy. All this drama had sucked the joy out of the experience of bringing a child into the world.

When I next conceived, none of us knew what I was having. I prayed the prayers to have a boy. I envisioned shapes of the boy stomach, with more on the front, and drew a picture of myself like it to look at when praying.

Finally he was born, my beautiful baby boy, Burhanuddin. Colicky, but he completed us all.

As a people, I wish that we could overcome our social and traditional ideology of wanting a boy. The feeling is oppressive and it kills a part of a mother's soul. I wish that I had not allowed myself to become so overwhelmed by it. I wish I had not succumbed to the pressures on me. I take responsibility for that. It turned me into a bit of a "zombie mom," unable to connect to what I really thought and cared about. After my experiences, I understand the importance of self-expression—of being true to your own feelings—and I intend to pass that on to my kids.

Being a mother puts me in touch with the miracle of life itself. Our children, no matter who they are, are our true gifts. Each second we get with them, we get to create beauty and peace and joy until they become masters of their own paintings and we become the admirers. ✧

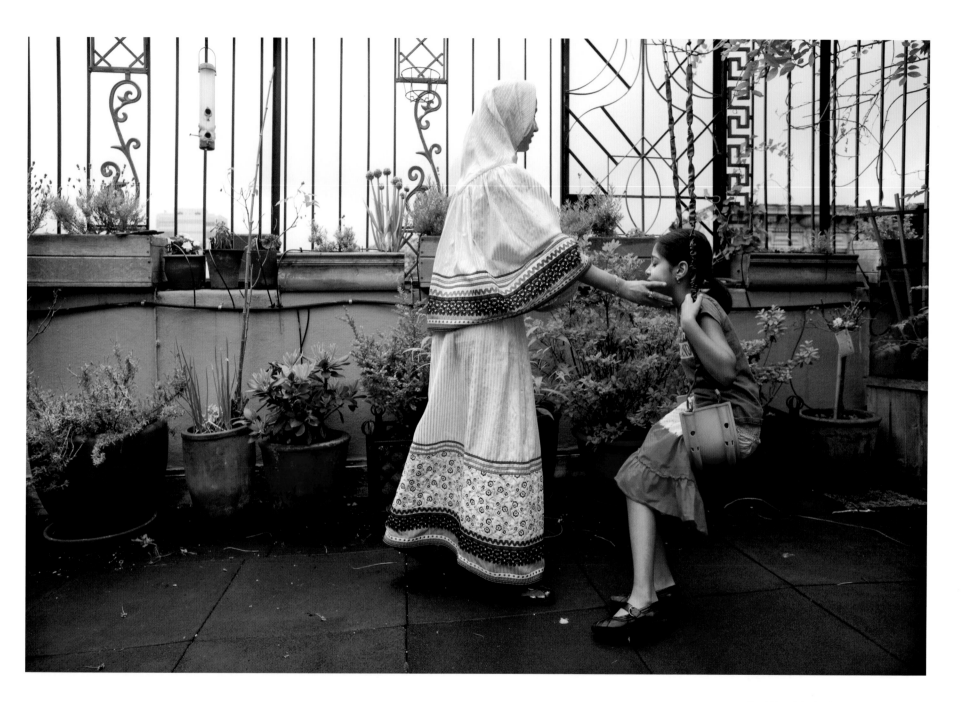

Rashida with Khadija on the Swing

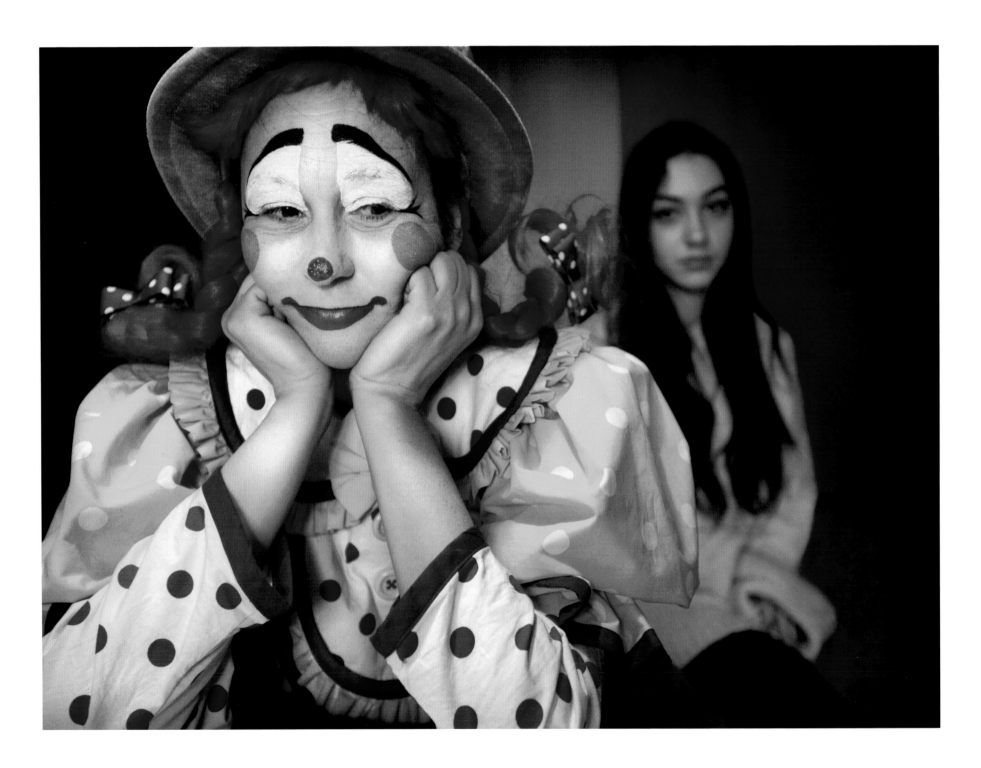

ERIKA "GIGGLES THE CLOWN" KIRKLAND I DISCOVERED, MUCH TO MY MOTHER'S CHAGRIN, THAT I COULD ACTUALLY MAKE A LIVING AND SUPPORT MYSELF AND MY DAUGHTER BY BEING A CLOWN.

I have good memories of my grandmother. She and my grandfather owned a tourist attraction in Lake Ozark, Missouri, called Dogpatch. There were lots of touristy shops, chickens that danced and played the drums when you put a quarter in the machine, go-carts, cotton candy, snow cones, artists doing caricatures... They would dress me up as a clown when I was a little girl to attract people to the place. Later in life, I studied the dramatic arts, and my love of theatre tied in well with this early experience. I've been supporting myself and my teenage daughter, Brittainy, as a full-time clown for sixteen years now. The question I get most often is, "I know you're a clown, but what do you really do?" They just can't believe I've found a way to be happy every day doing what I do for a living.

Brittainy has been working parties with me on and off for years. Originally, it was out of necessity because as a single mom, sometimes I didn't have anywhere to leave her when I had a gig. But it also became a great way for us to spend time together. I'd hate for Brittainy to look back and think, "My mother never had any time for me," which is how I felt about my own mother. She basically likes to work the parties, though she hates when she has to dress up as a princess. We've had a few run-ins with crazy parents, the worst of which was when one mother chased another around with a butcher knife because she ruined one of the balloon displays. We've seen a lot together. But that's the point. We're together.

As a baby, Brittainy never slept. For the first year, no one slept. She was an incredibly challenging two-year-old. Raising her and starting my own children's entertainment business, and making enough to support us with no family support, was not at all easy. She's never known her father. He was in a band and he liked the girl groupies a little too much, to put it nicely. We split up right after she was born. My boyfriend of thirteen years has been like a father to her, showing up at dance recitals, teaching her math and science, etc.

I believe support for your children and their dreams should be

one-hundred-and-ten percent. Take time to enjoy your children. Be there for them. Listen to them. Don't tell them their dreams are ridiculous. Again, there was a lot of that in my childhood. There still is. My mother never wants to hear about my clowning unless it's about the money I've made at it. I'm really happy that my daughter can see me enjoying what I do every day. I want Brittainy to feel that all of her dreams are possible.

Most adults carry on, day in and day out, at serious, dead-end jobs. My attitude is, maybe you should take a deep breath, relax, enjoy what you have, and have fun daily. The most important goals in my life are to be happy, successful, and have a good relationship with my child. People either think I'm crazy for what I do or they say they wish they could do something that makes them happy, too. ✧

Brittainy on Her Bed

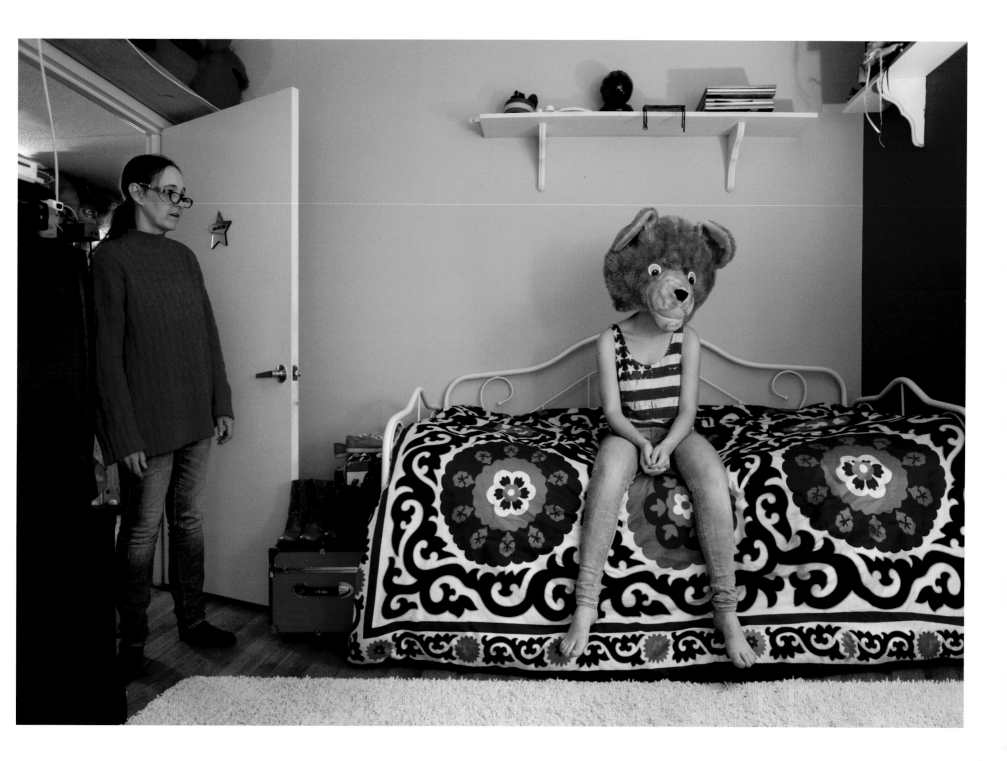

Alicia with Ari in the Subway

ALICIA MIKLES MY PARENTS WERE SIXTEEN AND SEVENTEEN YEARS OLD WHEN THEY UNEXPECTEDLY HAD ME.

They were together on and off during my early years, and divorced before I started kindergarten. I spent my childhood growing up way too fast, worrying about things children shouldn't have to: bills, turning the heat up past fifty-five degrees in winter, whether I'd have a winter coat and boots that would fit, moving yet again, my parents' emotions and problems. I spent a lot of time with my grandparents, who provided a kind of stability, but even this veneer was underscored by the simmering undercurrents and heated outbursts common in alcoholic families. Many of my family relationships have been fraught with high emotion, discord, a whirling sense of chaos, or an unsatisfying absence. I soon learned to minimize my own problems to others and then solve them myself. As a child I was good, quiet, neat; I excelled in school. I walked a line between invisibility and desperately wanting to be seen, to be recognized for who I was.

I entered the world of work as soon as I could, at sixteen years old, and have since then always had a job, always paid my way. After I gave birth to Ari at age thirty-four, however, I couldn't imagine return- ing to my job full-time. At that time I was an art director at a company where I had worked for twelve years. I loved my job, but I also wanted to be with my baby and experience this new life, his and mine. Unfortu- nately, our current culture doesn't offer extended maternity leave and this was the choice I had: my career or my child's childhood. I had a very cordial and mutually respectful relationship with my co-workers; when they offered me freelance projects, I thought that would be the perfect solution. But it is difficult to predict the ebb and flow of freelance work. When, after a few projects, things slacked off, I didn't pursue it as I might have done.

When I removed myself from the stable structure of the corporate workplace, I found it a challenge to advocate for myself, promote my- self, effectively tap into my resources, and reach out to all my contacts and let them know I was available for work. Once things settle down with our babies and our lives return to feeling somewhat our own again, I feel it's appropriate to again have the opportunity to feed, house, and provide for those children, and to reconnect with our professional lives.

After I left that position, I realized that although I did have a separate identity outside of work, as an artist and performer, my sense of self was still very intertwined with the work I did for pay. I hadn't put as much value into my personal work as it didn't generate my income. As an art director, I had earned a certain level of respect. I knew what to expect each day, how to accomplish my tasks, and exactly what steps to take to do them efficiently and extremely well. I relished the detail-oriented, organizational quality of the work. I felt in control.

As a new mother, things were thrown my way that knocked me for a loop. I felt like a complete failure, for instance, because I could not get my baby to sleep for what seemed to me an eternity. I spent my waking hours exhausted, trying to get him to nap for more than fifteen minutes in the day and to sleep for more than a two-hour stretch at night. When he finally did sleep, I found I couldn't. My sleep cycle had been thoroughly disrupted. I remember seeing an acquaintance in the park one morning as I walked our dog, with Ari in the stroller. When she casually asked, "How are you?" I burst into tears. I found that for the first time in my life, I needed to ask for help. I couldn't always do it all on my own as I had so diligently taught myself to do. I sought help for and was diagnosed with postpartum anxiety and depression; I found it was difficult just to get through the day with my baby, let alone start building a new business. We had decided to leave the city and find a house in upstate New York, so between the new baby, leaving my job, and buying the house, I had reached my limit.

I allowed myself to take a bit of a break from work for a year, and then started my own graphic design and art direction business, encouraged by a very supportive friend in the industry who had moved way up the career ladder. I look at my friends and former colleagues and at times wonder if the road I didn't travel is an easier one: a steady, well-compensated job, no worries over health insurance (as an independent contractor I pay over twenty percent of my earnings for a basic policy), no wondering when the phone would ring or the email "ding" with new work, the ability to pay into a retirement fund and increase savings. But then I saw how quickly this time with my young children was going.

I feel real pride in accomplishing what I have: a cobbled-together income from design, teaching yoga, and yes, even selling my artwork. I have an online vintage shop in the works. I'm invested in creating my own life, with my own valuable talents and abilities, visible for all to see. ✧

I FEEL THE OPTION OF EXTENDED MATERNITY LEAVE IS SO VITAL:

IT'S NOT ALWAYS POSSIBLE FOR SOME OF US TO JUMP RIGHT

BACK INTO OUR CAREERS.

NGODUP YANGZOM I LEFT EVERYTHING BEHIND TO COME TO AMERICA.

I came when I was in my late twenties, with only two hundred dollars. I had a friend who helped me for a month until I found a job in a coffee house, which I was determined to find quickly because I didn't want to have to depend on the friendship too much.

My parents left Tibet when China occupied it in 1959, and my siblings and I were born and raised in the village of Bhandara in the state of Maharashtra, India.

I had worked as a teacher in an orphanage in Nepal, so I had a little bit of experience with kids before coming here; eventually, I found work as a nanny. When I found my first nanny job, which was for a two-month-old, my daughter Chogkey was only eight months old. My husband drives a yellow cab and works all the time and I also need to work—so I needed to find a nanny for my own baby to enable me to work as a nanny myself.

In the job I have now, I take care of two children. The family I work for is very supportive and gives me time off if my child is sick, which is a very good thing for me, because my daughter has autism and needs lots of therapies and help.

Chogkey is totally nonverbal. When she was very young, she could say mommy and daddy, but when she reached around a year-and-a-half, I knew she had problems. Now she only makes noises.

While I am working as a nanny, my own nanny picks Chogkey up from school and takes her to her daily therapies, which end at seven o'clock. These include speech therapy, occupational therapy, and physical therapy, in addition to the one-on-one therapy she gets at a special school.

Chogkey works really hard to learn everything, but there are many things that are beyond her abilities. She still doesn't understand the concept of danger. She can't do the simplest things, such as feeding herself and holding crayons. At age five, she still needs diapers and doesn't know how to play with other kids her age. Often, when she is running around carelessly on the playground, I see other parents roll their eyes or give us dirty looks. I tell people she has autism, but most of the time they just don't understand—or don't want to. That bothers me and makes me sad. No one sees how hard she works—they just see that she's different. While other children are going to swimming lessons, music class, or ballet practice, she is working all the time.

I don't really have time to mourn or feel bad, though. I just keep

Ngodup and Chogkey at the Swings

60

looking for what to do next. I wish I could give her all of the care and special treatments that mothers with a lot of money can, but I do my best. I wish I had more time to just be with my daughter, but right now I need to work. and she needs to have all these therapies in order to improve.

In my country, women are always in the home, taking care of their children and the house. The men go out and earn. But now we are in America. Here, men and women both go out to work and at the same time men expect women to do the housework, cook, and take care of the children. So my responsibility as a woman has doubled, and without any family here to help us it is very difficult at times.

Back home, women are not treated as less because we stay home. The expectation is that we will take care of the family and we feel respected for it. Still, when a boy is born the family is very happy—but when a girl is born the family is not so happy. So I guess there is still inequality.

Many of my friends from my village did not continue school after high school because they thought, what's the point? Women are expected to learn how to knit, make carpets, take care of the animals and the farm, take care of the kids. I might be the first girl from my village to go to college and I was born in 1977—not that long ago.

These expectations are starting to change: more girls are staying in school and eventually working outside the home. But as the opportunities become greater, the expectations and pressures do also. That is why it is good when they have extended family support to help raise their children.

Emotionally, I think that if I were back home it would be better for me, but for Chogkey, I think it's better here in America, where she can get all kinds of services. In my country they don't know what autism is. They just call kids who have it "retarded." Here, I can work and send a little money back to my family and Chogkey can get what she needs.

And even though we face these challenges together, she is very happy. When I come home from work, Chogkey likes to open my bag because most of the time I have something for her—toys, lollipops, or special treats. Every evening we go to ride the little mechanical horse outside our local store. That's like a ritual for us. Sometimes, when I am on the computer, she comes from behind and gives me a hug around my neck. Although she can't speak, Chogkey can kiss and she kisses me often! And in my country we do not hug but we do ooh dhuk—which means, touch heads. When Chogkey and I do ooh dhuk, that's when I really know how much she loves me. ✧

Chogkey in the Window

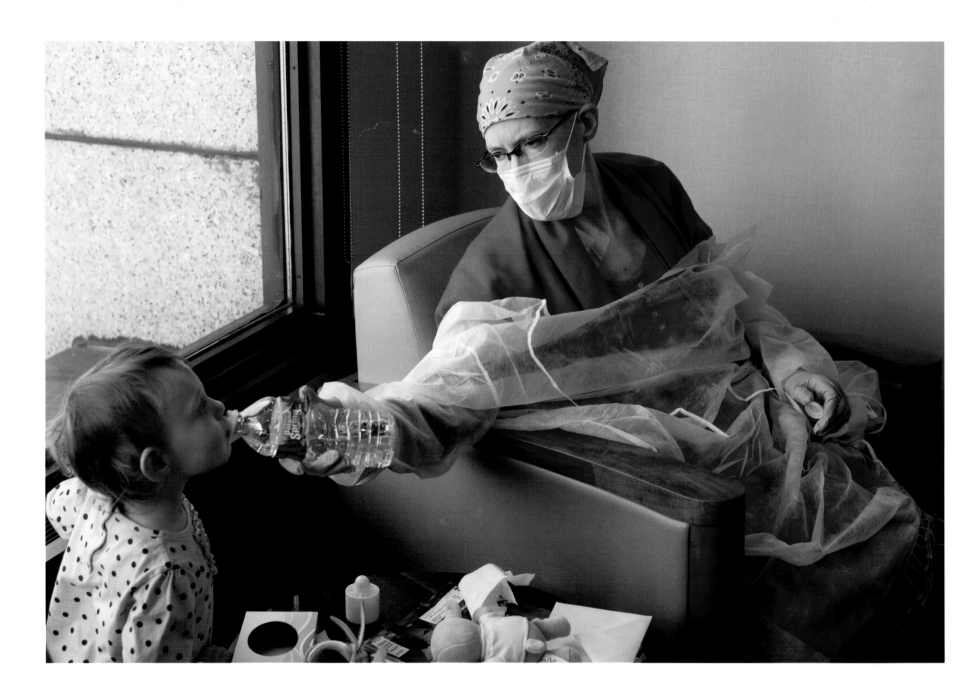

Diana in the Hospital

DIANA JOY COLBERT I DON'T KNOW WHAT KIND OF MOM I WOULD HAVE BEEN IF I HADN'T GOTTEN SICK.

When our daughter was six months old, our marriage was in crisis. We decided to spend the summer in New Hampshire, in the country, in a beautiful place; we thought, if we can't make things work here, then we can't work them out. We were there for three weeks when I got a really high fever. A few days later I coughed up blood, so we went to the emergency room where they were sure I had pneumonia, but needed to wait for the blood results to come back confirming it before sending us home. We waited there for hours until the doctor finally came in and said he'd had to rerun the blood tests because he didn't believe the results. "You might have leukemia," he said. "You have no white blood cells. You have no immune system." I'd have to be hospitalized immediately.

Charles and six-month-old Lily got into their car and I was taken in an ambulance at night somewhere an hour-and-a-half further north, to somewhere we'd never seen in the daytime. I knew my daughter and husband were out there in the dark. He'd never driven anywhere with just her alone in the car, and she was almost exclusively breastfed. That was stressful. I got to the hospital at around nine-thirty at night and they followed at eleven, soaking wet, looking shattered. That began a month-long stay in this hospital in New Hampshire where they con-

firmed that it was leukemia and started me on chemotherapy.

Lily hadn't spoken yet. I had no idea what her voice would sound like, and I just kept thinking, "I have to hear her speak...I have to see her walk."

Overnight, Charles and I put all our problems aside and decided we were gonna make it through this. So leukemia sort of saved our marriage, weirdly enough.

When Lily was ten months old, we were apart for a month while I got the first bone-marrow transplant. In a very hard situation, that was the hardest thing. And now I'm looking toward another month when I'll have to be away from her because I came out of remission right before the one-year anniversary of my transplant. The leukemia came back. I was totally blindsided.

Being apart from Lily gives me time and space to concentrate on my healing, and I see how necessary that is. But there's a layer of guilt, even though I didn't do this to myself. I have abandonment issues from my childhood and I just don't want her to have them. I don't want her to think that I'm not around for any reason other than what's true, but I don't understand how to explain what's true to her. My mind is used to

finding a worry and bringing it to me, and this is always there to worry about: How is this affecting Lily? What am I doing wrong? How is she taking this in? I don't know what to do other than prepare her for each thing as it comes up. I wish I could say that this experience has made me a better mom, but I don't think that's true. But it may have made me value her more, and value being her mother more.

I had such a magical time with Lily her first six months. I was teaching two days a week and I had a babysitter at school. So I'd take her to school on the bus and I'd get there and hand her over, go upstairs, teach classes, and as soon as I was done I'd get her back and breastfeed her in the faculty lounge. And it was just...the greatest thing ever. I loved teaching more than anything before I had her, so it was the best. I was fulfilled intellectually and fulfilled as her mom. Those days were the sweetest, sweetest days. I knew how sweet they were, but I wish I had known how fragile it all was, that it was going to be ripped away from me. That was harder than losing my hair. It was harder than the skin rashes. It was harder than the fear. It was harder than losing all the weight.

When I got sick, we had to change health insurance because my student insurance was not going to pay for the transplant. We went from paying ninety dollars a month to paying twenty-five hundred dollars a month. Charles is a novelist. It took him ten years to write his first book. The money he made off of it was meant to last us ten years and now it's gone to fulltime childcare and health insurance. That's it.

Over three months of my life have been spent in a hospital. A year of my life has been spent wondering if I'm gonna die before I'm forty-one and how my daughter's going to grow up without a mother.

But, you know what? Things are gonna work out. It looks very grim but I can't dwell on what we don't have because we have so much. Leukemia really focused me and made me realize how beautiful my life is and how much love I have. We have so many people willing to help that I just need to focus on that. We're not gonna starve. We've still got friends and family. The universe is an abundant place and I just feel like we're gonna be taken care of.

And being a mom inspires me to get better. I know two people—one of them was an orphan and the other's mother died when she was fifteen—and they're both great people. They both turned out great. I think Lily would turn out fine without me, but I just don't want her to have to. I really want to have a friendship with her while she grows. I want the privilege of watching her become a person. And that inspires me to do whatever I have to do. I want to see her as a teenager, a twenty-year-old, I wanna see who she becomes. To fight for my own life just for me would be so much harder. But it's not just for me. I'm not alone in this.

Once, when I was talking to my husband and daughter from the hospital on the computer, she was crying and I said, "Can I sing a song to you?" She said no but I sang the song anyway, and she stopped crying and just listened, with these huge eyes full of tears, just listened to me singing this song I've sung to her since she was a baby. And when I was done, I said, "All my love for you is in my heart and your heart. And your love for me is in your heart and my heart. So we're not really separated." And I felt like she could almost get that, you know? I hope she could almost get that. ✧

Diana Holds Lily Outside

Jack and Karen in the Pool

KAREN DUFFY I THINK MY SURROGATE AND I WILL BE FRIENDS OUR WHOLE LIVES.

I didn't think much about having kids during my main baby-propagating years. I didn't come from a wealthy family, but I've always felt really lucky and grateful for everything, and I wanted to live my life in service. I went to school for recreational therapy and that was the trajectory I was on. But one night I was at a bar and a man asked if he could photograph me. That man turned out to be Richard Avedon, and that experience changed everything, leading to a career in entertainment and modeling. So that became the focus during my twenties. In my early thirties, I was diagnosed with a chronic, life-threatening illness called sarcoidosis. I went on to develop tumors everywhere—on my brain, my uterus, my lungs. It quickly became unclear if having a child would even be an option for me. I couldn't carry my own because of all the morphine I had to take and because of the chemo. Every week for five years I'd get an injection of methotrexate, which is an abortive agent. So it wasn't lost on me that what kept me alive for years was also prohibiting me from having a kid in a "normal" way.

When I met my husband, John, he knew he really wanted kids. My doctor actually took him out for drinks and told him that if I were to get pregnant, we might actually have to choose between my life and my baby's life. So the journey into motherhood through surrogacy really began for John.

Funnily enough, we found our surrogate, Breena, through the world's most famous bachelor, George Clooney. He's been a good friend for a long time and is now Jack's godfather. We met Breena in the parking lot of an L.L.Bean outlet store in Freeport, Maine. I was like, "Man, why would you ever do this?" It was a huge commitment on her part for over a year. Other than carrying the baby and giving birth, she first had to commit to months of medication in order to stop her ovulation cycle so that my oocytes (I hate the word "egg") could take.

Every failure was really gutting. Before we became pregnant with Jack, we had agreed it was going to be our last attempt.

You have to get up really early and get to the doctor by seven a.m. You're there for two hours and there's not one happy face. There's no room to sit. It's packed. They'll do, like, a hundred and twenty women a cycle. If someone brings a kid, it's like they showed up with a bag of vipers. The level of anger and frustration in this place is so high, the women there can't deal with a little kid. It's an emotional roller-coaster and everyone's hormones are elevated. It was just amazing. I always tried

to make sure I was dressed up and my lipstick was on. I tried to be a bright light rather than a part of the negative bitchfest.

Surrogacy and IVF are very expensive (although there's a new trend of outsourcing to India). Women who pursue these options are usually those who've been very successful in their lives and often have put off marriage until they were settled financially. Then they realize that their window for having children is closing. They've succeeded at everything and they're damn well going to succeed at this.

That's how I felt: What have I tried that I've failed at? Nothing. I would just keep trying till I got it done.

So there were these women who were very aggressive and pushing through the revolving doors and sitting in this room with a rictus of angst on their face, trying to get to work afterward. But after a month of being stimulated and finally returning so they can retrieve your eggs, you are in a room full of women there for the same reason and the mood changes. You have to get there early and be scrubbed for surgery and you sit in this tiny room, wearing hairnets and in gowns and bare feet. You're so exposed that you're literally holding hands with the other women and saying, "Good luck. I'm gonna pray for you." It gets really intense in that room.

I remember sitting in the car once and Jack was in the baby seat. I was looking at him in the rearview mirror and I had this moment of satori, like, Okay, I get it. I understand absolutely why we had all those failures. It's because his soul was destined to be in this family. He was my family, I just had to wait for him. It hit me and I thought, All right, I accept everything else that has happened. ✧

BREENA SAID, "HOW MANY TIMES IN LIFE DO YOU

GET TO DO SOMETHING THIS BIG FOR SOMEONE?"

THAT SOLD ME RIGHT AWAY.

JEN FUGLESTAD I HAVE TWO DAUGHTERS WITH MY HUSBAND NICK, AND I ALSO HAVE A SIXTEEN-YEAR-OLD DAUGHTER, BELLA, FROM MY PAST RELATIONSHIP WITH DAN.

My parents split when I was nine and my two sisters and I were raised by my mother. My father was in the army and was often stationed abroad, so we didn't see him much. He remarried while I was in my young teens and slowly drifted from our lives. Our relationship has only recently been strengthening over the last five years, thanks in large part to his current (third) wife.

I always give credit to my mother because in all those years that my father was a deadbeat dad, she never once badmouthed him in front of us. I really respect her for that. It must've been very difficult. I think, because of missing him so much during most of my life, I've placed a lot of emphasis on having a "whole" family, despite the fact that Bella's dad and I split up.

The first time I met Lindsey, Dan's current wife, she was managing one of his restaurants. I knew the second I met her that she and Dan would hook up. She was pretty much the ultimate nightmare: six feet tall, super-short bleached-blonde hair, lots of tattoos, a good eight years younger than me, with a completely flat stomach… I'd be lying if I said I wasn't giving her the business a little bit!

It turns out I couldn't have been more wrong about her. Sure, she was a hottie, but she has a good head on her shoulders.

Bella immediately fell in love with her and I think it was mutual. Lindsey has always respected my role as Bella's mom and has never tried crossing any lines, though I wouldn't necessarily mind if she did, as we seem to share many parenting philosophies. Over time we have all become a united front in promoting Bella's best interests.

Dan, who had halted our relationship when my current husband and I started dating, began softening toward me once he and Lindsey got involved. He was happy. I was happy. Bella was happy. Bingo. Soon we were all spending holidays together and our modern mixed-up family became the new "normal."

I have always been a "chicks have to stick together" kind of gal. I've found it disconcerting how competitive and catty some women are with each other. I think having only sisters and being raised by a single mother (and now having daughters), I've seen firsthand the importance of women supporting one another and not tearing each other down. ✧

LINDSEY BLISS I HAVE FIVE BIOLOGICAL KIDS AND A TEENAGE STEPDAUGHTER, BELLA. I LOVE MY STEPDAUGHTER AS IF SHE WERE MY OWN,

but I leave the real parenting and decision-making to her parents. She respects me as an adult that loves the hell out of her and wants her to be safe. I give my opinion when asked, but try not to cross any boundaries.

I have parents that went through an extremely messy divorce. They argued a lot and avoided each other at all costs after the divorce was finalized. I think that my parents' inability to get along during their breakup initially turned me off of the idea of marriage and kids.

But I love big families. I have a brother and a sister and, as kids, on the weekends we went to my cousins' house where there was a total of seven kids. I loved spending the weekend with them. I remember how much fun I had playing and causing trouble. It makes perfect sense, now that I have six kids myself. Holidays were always my favorite times and now, with my kids and Jen's, our holidays are extremely festive.

I have always been amazed at how well my husband Dan gets along with his ex. They work as such a great team to raise Bella. They don't always agree on everything, but they never really let it get too heated because they never lose sight of what is important: their daughter.

It was easy to like Jen. She was a devoted, loving mother that wanted the best for her kid. I don't feel that either one of us has any hang-ups or jealously issues. She's always been super sweet and friendly to me so I never had to try to like her—I just did.

It's hard for me to understand stepparents who have issues or drama with the biological parent. I know some ex-partners aren't going to be your best friend, but you have to put your crap aside for the sake of your kid.

I feel that devotion and love make a mother and a family. ✧

Jen, Lindsey, and Their Children

LAUREN RIDLOFF MY FEELINGS ABOUT HAVING A DEAF CHILD ARE MUCH DIFFERENT FROM THOSE MY MOTHER EXPERIENCED.

My son Levi is five-and-a-half months old. My mom recently anointed him "Other Way"—like a Native American name—because he just started crawling backwards, and if you hold him up to see something, he looks in the opposite direction. We haven't come up with a "name sign" for him, but we're leaning toward the sign for "other."

My husband Doug comes from a family that is primarily hearing. Although he has a few relatives with some hearing loss, he is the only one who is profoundly deaf. I'm the only deaf person in my family. For the longest time, my father and mum thought it was a result of something they did wrong, and I know my mum suffered guilt for years because of that sense. But now that we have a deaf son, it's apparent to everyone that it's genetic. That has been a visible relief for her. I have an older sister, and we talk about how we grew up with very different mothers—a more carefree, maybe careless mother for my sister, a loving, maybe overly attentive one for me.

Levi helps me see who I really am, how I react, and what my decision-making process is. He makes me more aware.

I actually feel a bit guilty for finding myself relieved that my son is not hearing. I'm a teacher. I teach hearing children of deaf adults (they're called CODAs). Their first language in the home is American Sign Language, but their natural language is spoken English. CODAs are a fascinating group of people. They are bilingual and bicultural. Many CODAs are fluent and comfortable in both English and ASL. As they straddle both worlds, some of them struggle to find a foothold in both the hearing and deaf communities.

During my pregnancy, we were positive that Levi would be a CODA, a hearing person born into a deaf family, and we felt prepared for that. Doug and I both teach CODAs and we can each empathize with being the odd one out in a family. We have many friends who are CODAs and I envisioned myself asking them for support and advice.

My midwife was the first to suspect Levi's deafness, soon after his birth. She noticed that he wouldn't flinch at loud noises. We had him tested and he failed the first, second, and third tests, so we were referred to Cornell Weill, a hospital with a renowned pediatric audiology department. By the fourth test, it was determined that he is profoundly deaf, like his mum and pop.

I was shocked at how excited and happy I was when I got the news. My reaction bothered me, made me feel guilty, thrilled me, and made me anxious, all at the same time. I imagine it's a bit like how gay parents might feel if they discovered their child was also gay—it opens up the possibility of sharing a culture, experiences, language, interests... yay!! But of course one is also worried about how crazy the world can

be for people who are different, and how ignorant people might be toward your child.

Many deaf children do not engage in pretend play. Imaginary play, having imaginary friends, and other things like that, are the result of the incidental learning that happens when children hear their parents talking. For example, a child might hear, "Oh, honey, we're out of milk." "Okay, that means I have to go to the store to buy more milk." "While you're at the store, will you please get some strawberries?" That kind of dialogue, so unimportant yet so vital to learning, is what deaf children miss out on when they grow up in an environment that is mostly spoken English. They lack exposure to casual conversations and background information. They have no idea that when there is no milk, someone goes to the store to buy some. They don't know that a food store is where one buys milk. And they don't even know how one asks another person to do something. They are able to role-play, to pretend, but only within a limited perspective...their own.

Deaf children of deaf parents, or of parents who sign, are able to see that kind of talk, and as a result they understand that milk comes from the food store. Deaf-of-deaf kids engage in pretend play, role-playing, and made-up dialogue because they have something to draw from. Because Doug and I are aware of the importance of those seemingly mundane conversations, Levi is going to grow up in an environment that is readily and absolutely accessible to him.

So hell yes, I feel lucky to be here to help guide him! Levi chose the right set of parents, in my opinion. He may grow up and beg to differ, but right now it's working out just great! Levi has a father who creates gorgeous ASL poetry and stories. Doug is into the visual ver-

nacular of ASL, so Levi is exposed to that. I was Miss Deaf America in what feels like another lifetime. We are culturally proud—we basically just see ourselves as a linguistic minority. My hope is that Levi will grow up secure, not having to think about or fight for the deaf part of himself. I want him to grow up thinking about other things. ✧

I UNDERSTAND MY MOM AND HER MOTIVES

A LOT MORE NOW THAT I AM A MOM MYSELF.

TRAE BODGE NAPIERALA I THINK THAT PARENT-CHILD BONDING CAN HAPPEN IN A LOT OF DIFFERENT WAYS, AND TO SAY THAT IT'S INSTANTANEOUS FOR ALL WOMEN IS A LIE.

I was adopted at eight weeks and have these amazing parents that I'm so much a product of. I'm a huge proponent of adoption and think a lot of people get it in their heads that you can never really bond with a child if he or she is adopted...at least not the way you would bond with your biological child.

I grew up in a family where no one looked like me, where I was this unique little creature. My sense of belonging came from communication and acceptance. You don't need to resemble your family to feel like you belong, but I think that many adopted children, whether they felt like they belong or not, often feel a strong urge to clone themselves in order to experience a familial resemblance.

I fantasized that I'd have this brown-skinned, curly-haired girl as my daughter—a "mini-me." It's a strange impulse that I think drives many people to have children. But Sadie has really fair skin and doesn't actually look much like either of us.

Maybe in part due to this lack of resemblance, the bonding wasn't entirely immediate. We bonded more similarly to the way an adopted child bonds with his or her adopted mom. Because she only started to resemble me after we had bonded on that other level, the resemblance was like an unexpected treat—like when you've had the most amazing meal and you are totally sated, and then the chef sends over a bite of the most delectable dessert and you think, "Wow, I didn't think I needed anything else, but this is amazing!"

Another factor that impeded immediate bonding was that Sadie was born at twenty-nine weeks and weighed a mere two pounds, fifteen ounces.

I think pregnancy lasts nine months for a reason. You go through an extraordinary amount of emotional change and a lot happens to your body and mind during that time. You've had a person inside you that you've been thinking about and caring for and bonding with as much as you can without having met them. You've already begun your relationship with them.

When you give birth suddenly at twenty-nine weeks like I did, you haven't even really wrapped your head around the fact that you've got a real baby. When I unexpectedly had this baby through cesarean, I felt really detached from the experience. She was placed in an incubator.

Trae and Sadie at Lunch

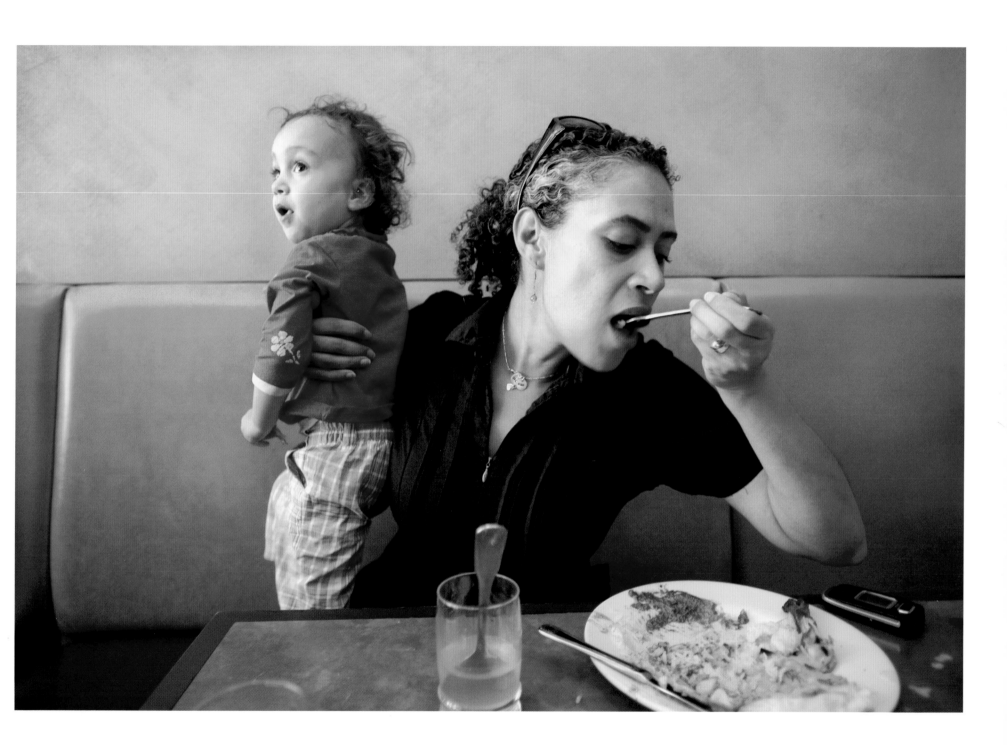

They told me I couldn't see her for twenty-four hours after the birth and I thought, "Okay, I'll see her tomorrow." When I saw her for the first time, it was shocking. She was so tiny and she was hooked up to an amazing number of wires and tubes. It was really weird.

When I got home I didn't have a baby to take care of, so I went back to work after a week. The hospital was near my office, so I'd visit her on my way to and from work. By the time she came home at forty weeks, she'd been in the hospital so long she wasn't interested in nursing, so I was robbed of that bonding experience as well, which I was a little bitter about.

I loved her instantly, cared for instantly, took care of her as soon as I was allowed, but I didn't understand the intense bond that other mothers described. For me it took some time. For me it was a process. Then, over time, as she started smiling and I cared for her consistently, it developed.

Maybe in relationships where there is strife—for instance when the woman gets pregnant and the couple is not that close—fathers don't put in the kind of time it takes to bond with their kids. And, because they haven't put in that time, they never understand that deep bond. Maybe that's why some men stay detached and just turn away and make a baby somewhere else. It's not always organic to bond. Sometimes it takes time.

Whether you bear a child or adopt one, there's just no guarantee that that bond's going to be there or that you're going to have things in common. You can't ever predict that. It takes effort and luck. You can bond with anyone. If you have the commonality, you can fall in love. ✧

LYNDA COHEN KINNE THE BIRTH OF OUR DAUGHTER VICTORIA COINCIDED WITH NEW YORK FASHION WEEK, WHEN WE HAD AN ENTIRE WEEK OF PRESS APPOINTMENTS SET UP TO PROMOTE OUR CLOTHING LINE.

While I was pregnant, we'd chosen to hide me from the press. The fear was that we would come off as too much of a mom-and-pop organization, what with us being a couple in business together and me visibly pregnant. But I'd given birth by the time press week rolled around, so we figured it wouldn't be an issue.

We didn't have a nanny, and trying to quickly find a great babysitter in New York City...well, you'll have more luck finding the last unicorn! If you do find one, nowadays, you're supposed to do a background check and it's a long, involved process.

We hadn't found anyone to watch Victoria yet and our publicist, who had a child as well, said that she was sure her nanny would be happy to help us out. That was a great relief. So we get there the first day of press week and I'm dressed to impress, wearing a corset, an elaborate Victorian-inspired skirt, a tailored shirt, a tie, and heels—totally done up. I'm standing there, holding two-week-old Victoria, next to my husband who's also impeccably dressed, when our publicist shows up with her child and nanny. We're introduced, we chat for a while, and then, much to our surprise, they say goodbye and leave...without Victoria! We

would soon come to find that our publicist was always making promises she had no intention of keeping and that she'd never even mentioned the idea of watching Victoria to this woman.

I distinctly recall thinking, "Well, now we're screwed!" For that entire week, we discussed high-end fashion and our international success with the press, and there was Victoria in her little robotic swing right next to us, rocking back and forth. It was a fifty-fifty split between interviewers who had kids themselves and totally understood, and young girls who were really into being "fashion people" and looked at me like I'd just stepped in dog shit. Clearly, their attitude was, "I'm a successful woman and you're a loser because you have a kid that you bring to work."

You can tell when you instantly go from being just ordinary people to being "people with children." It made me feel uncomfortable at first, but I learned to just suck it up. It was the first in a long series of lessons that made me realize I would only be happy as a mother once I actively decided not to give a shit what anyone else thought about me. ✧

Lynda with Victoria and Her Hurt Head

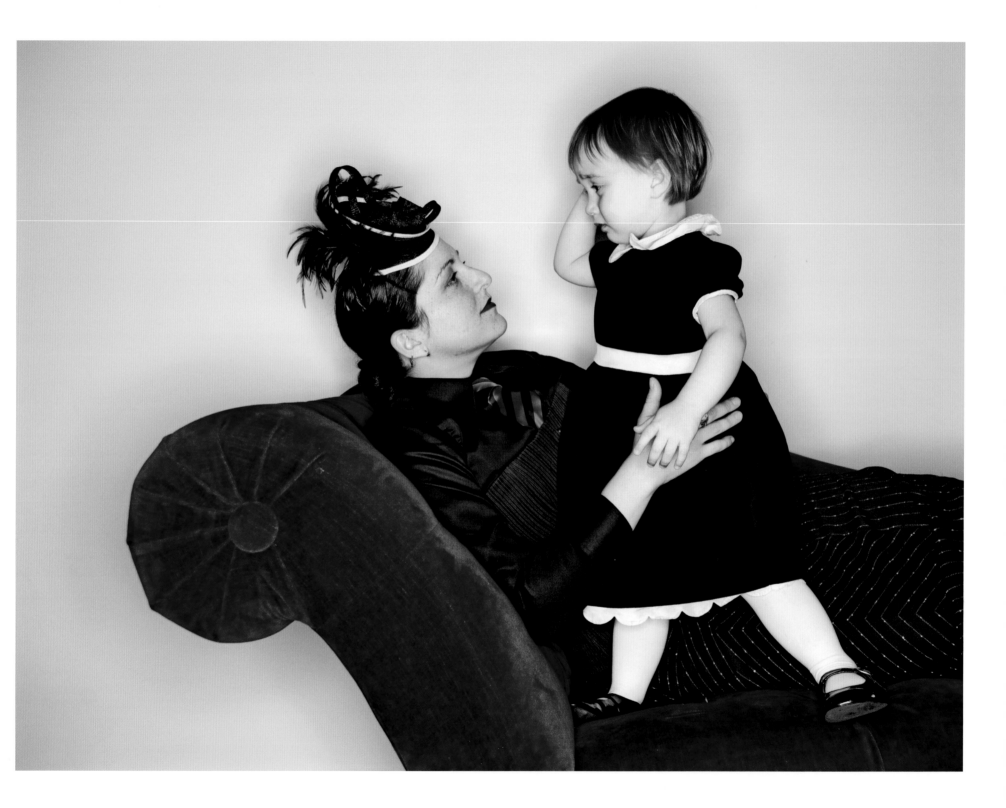

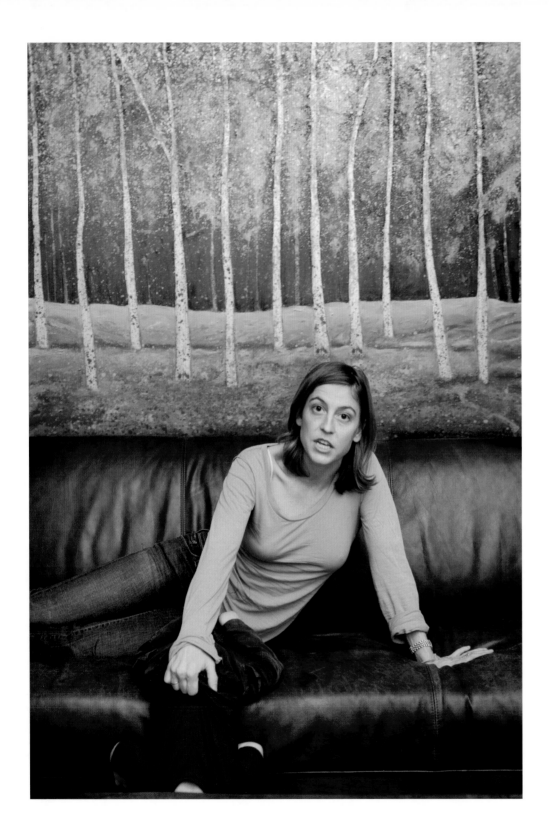

Amy and Beckett on the Couch

AMY RICHARDS MY MOTHER LEFT MY FATHER TWO MONTHS BEFORE
I WAS BORN BECAUSE SHE DISCOVERED HE WAS DECEPTIVE.

Among other things, he'd lied about being in medical school. She received advice consistent with the era: "Keep your marriage together at all costs." When that failed, she received more advice, also common for divorced women of the time: "We can help arrange for an adoption." She opted, instead, to head out on her own, which was hard but also empowering: a way to prove that she could thrive when others doubted it was possible. Luckily she was able to go live with a supportive sister.

College was the first time I started to question whether I'd missed out on something by not having a father, so I sought him out. I never did meet him, but I talked to his parents, who told me they hadn't talked with him since he'd been let out on parole after being in prison for kidnapping. If I had gotten a different response, such as, "He's living out in Westchester with his two kids and his wife," maybe I would have felt bitter. But as it was, even though I'd never really felt like I'd missed out on anything, I felt even more justified in my feelings. I didn't feel a pining for my kidnapping, lying father. At some point, there may have been a longing for that image of male heroism and stability, but the reality made me appreciate even more my mother's foresight in leaving him.

There's definitely much more pressure on men than there ever was before to be present dads, but when I look at so many men in my life and how they define being an available dad, it's basically going out for breakfast on Saturday with the kids. It's better than it's ever been, but I'd say it's definitely a far cry from what is expected of women. In my relationship, the childcare is very equal. However, I do make more money, so technically it should be my partner doing sixty percent of the child rearing and me doing forty percent. It might be "equal"—but it's still technically unequal.

I think the relationships that work the best are ones where there is more equality in terms of money and childcare, and a balance between work and home. I think the next step is for men to put pressure on other men. I don't think pressure can come from women alone to make this change, in part because that would mean that women were expected to carry equal weight outside the home, and I don't think a lot of them really want that. The Family Medical Leave Act applies to both men and women, and I think men in this country have to start saying to other men, "Dude, you didn't take your paternity leave? That's so lame!" ✧

TERRY BORN JEY HAD BEEN LIVING AS AN OUT GAY WOMAN
FOR TEN YEARS PRIOR TO HER SECOND "BIG ANNOUNCEMENT."

She came out to me as a lesbian in her sophomore year of high school. It was Mother's Day and she said, " I want to take you out for breakfast. I thought we could talk." Ninety-nine percent of me knew what this conversation was going to be about and I was kind of relieved that the issue would now be in the open—and that she trusted me enough to tell me.

On the other hand, even though half our friends at the time were gay, there was this tremendous fear I had. I had had an ugly and scary adolescence. I had very difficult parents who made my life pretty miserable and were extremely controlling. I had to work hard to gain a sense of self-esteem, had very few friends, and didn't start dating until late. When Jey came out as a lesbian, I thought, she's going to have to go through the same things but it's going to be even more difficult for her. I was just uncomfortable with myself, but she's going to have to deal with the discomfort of everyone else.

I didn't know the half of it.

My daughter had always made good decisions. She was never into drugs or alcohol. She became a vegetarian at twelve. In many ways, she'd always been conventional and responsible. And she had always had incredibly good relationships. When she came to me in 2001 and told me she intended to have gender reassignment surgery, I couldn't write it off as a bad decision. Still, I wondered if it was a phase—like her commitments to music and karate had proven to be.

This was my only child. My beautiful little girl. She was gorgeous as a girl. (He's now an adorable boy.) I suffered from intense loss, anger, and confusion at first.

It was four weeks between the time she told the news to me and my husband and when she went through with the surgery. There was no time to say anything about it. Jey was working through her own stuff and I think she knew that if she talked with us too much about it, it might shake her resolve to do it. That was the hardest part. To know your child is out there in pain, going through something difficult, and there's nothing you can do to help.

My husband and I really talked about nothing else for a long time after the news. There were conversations every day—any time we could find a way to rethink or re-approach the situation. I insisted that we go to therapy together, to break through that wall. Jey joined us when he was physically and psychologically ready—about two months later.

It took a year of intense therapy to understand that my perceptions of right and wrong, true and false, aren't necessarily my child's—and that that is okay. I had to separate myself from him and not blame myself. You can't only love your children when they go along with what you think is right.

As a family, we didn't exactly come to acceptance simultaneously, in sync with one another; but it has been getting progressively better.

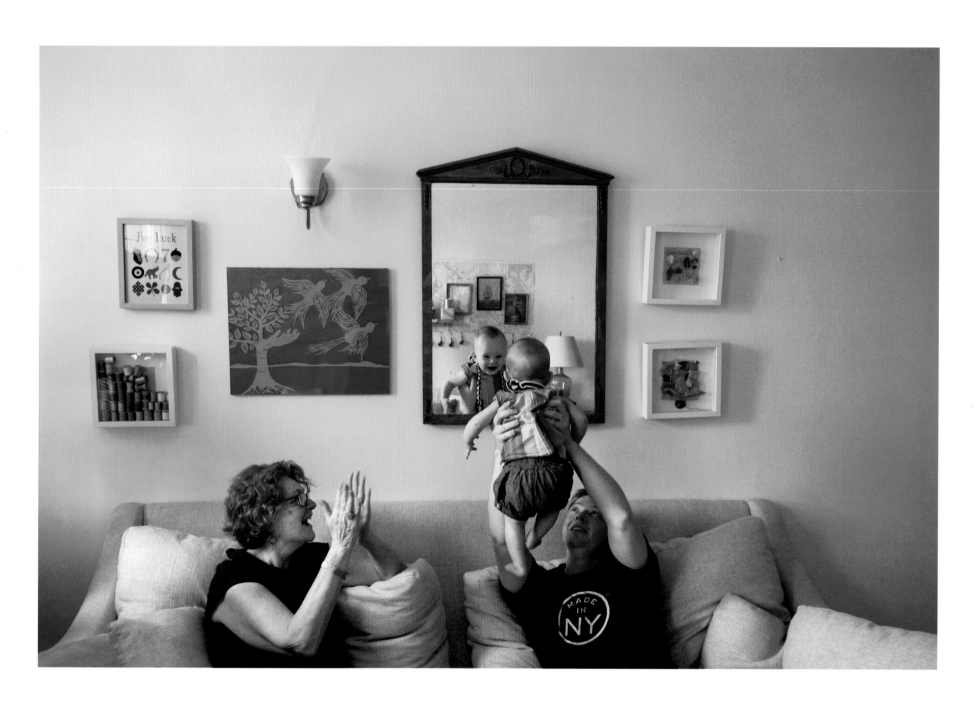

Terry and Jey with Lusa in the Mirror

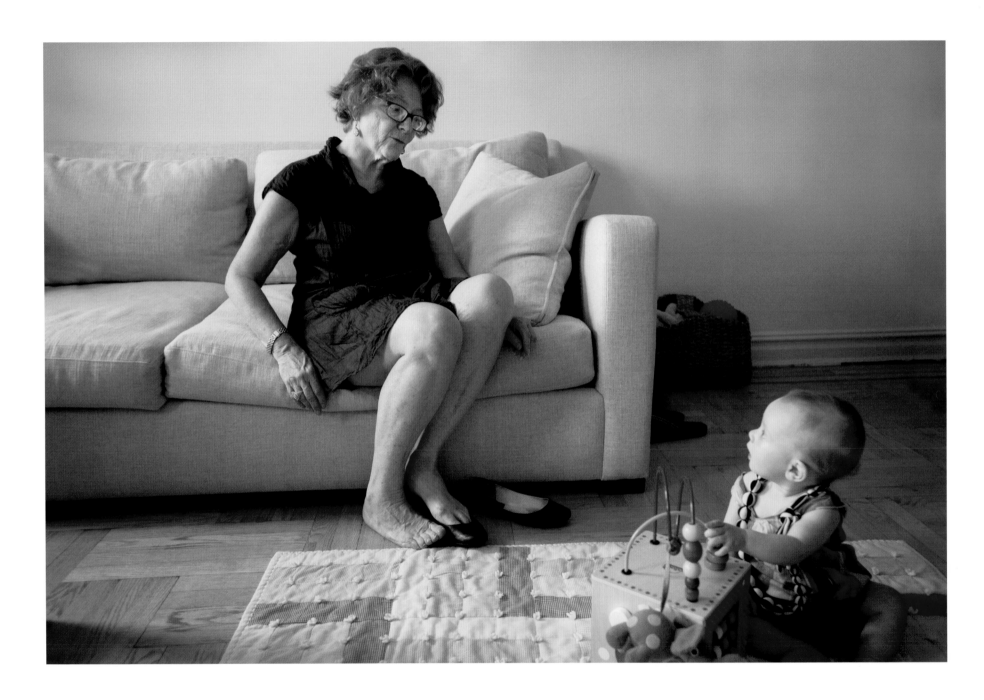

Terry and Lusa

As parents, we went through what a lot of psychologists call a period of mourning. Your reality has to undergo a transition and you have to let go of the things that you thought you had and find your way toward the things that you have in reality.

I thought the reality of having a lesbian daughter was this: I wasn't going to see my daughter get married and she would never have children. (In those days, gay marriage wasn't even on the horizon, and gay parenting was not an accepted option.) As a man, Jey is currently married to an amazing woman whom I love dearly. She couldn't be better and they have a lovely daughter together. These are unexpected gifts in my life that I never would have seen coming.

Open-minded or not, it's very, very hard to accept your child's decisions when they differ from what you'd want for them. For instance, when Jey was growing up, I expected a certain intellectual rigor and interest in things. Very honestly, I was disappointed that she really, really hated school. And books. And reading. My husband is a journalist and I'm a teacher, so naturally we hoped our child would enjoy these things as we did. (It's funny but once Jey really became who he was meant to be, physically and emotionally, he actually began to love these things. Today he is a voracious reader, knows more about politics, current events, and the economy than me, and is interested in learning all the time.)

But I had made a conscious decision as far back as high school to be a different type of mother than my mom was. I read Betty Friedan and decided I wouldn't do what my mother had done. She had lived her life through me and whatever I gave back to her was the determining factor of her happiness or unhappiness. A Holocaust survivor, her life was so horrible that she invested in me everything that had been missing for her. While she loved me and protected me unequivocally, and gave me everything that she could possibly give, she also put a whole bunch of burdens on me. The fact that my mother had nothing else to hinge her identity on except her motherhood was a big problem that created a lot of pressure for both of us.

So, when I had my own child, I made a commitment that I'd let my kid be whatever he or she wanted to be and I would just accept it. Now I know: we can tell ourselves that intellectually, but it doesn't really happen like that. Whether it's because we're disappointed that we don't get what we expected, or we have this inbred DNA, we are plagued with certain expectations we can't shake.

It's challenging to come to the point where you can say, "What I wanted isn't really what's important. What's important is that he's happy and safe and content with his life." I know now that ultimately, his choices are not a reflection of my worth.

I had to ask myself what it was that I really wanted. What I wanted, more than anything, was for my child to be in my life. Was this struggle to accept Jey's decision to change gender worth losing that? I guess I finally realized that any moment lost to misunderstanding or discord between us would be a huge loss for everyone.

There is an essence of motherhood that experiences a joy in what you gave birth to—that appreciates the special "good" and "uniqueness" of your child. That's what I came to understand, and it transcends gender, expectations, and everything else. ✧

ERICA LYON MY FIRST PREGNANCY REALLY HELPED SHAPE ME, BOTH AS A MOM AND A PROFESSIONAL.

I was really young and healthy. To be fair, I was also clueless about pregnancy and birth and postpartum and parenthood. I think that impacted some of my initial reactions.

I started my care with a very straightforward obstetrician and I was really surprised by how I was treated. He didn't respond well when I had questions about what was going on and didn't explain things well. I hadn't had my confidence in myself and my body eroded, yet and I believed that this should naturally be a joyous event and that my OB would be very nice to me. I soon realized that that was not the type of relationship he had in mind. In his mind, he was the authority and I wasn't supposed to ask too many questions or be too involved in what was happening to my body. For instance, when I asked why I needed a sonogram, I was told, "Well, don't you want to know if your baby has one arm?" It startled me that someone would give an answer that was so clearly designed to frighten me instead of saying something reasonable like, "This is a routine screening and we check for things like kidney and brain growth." Instead I got an answer designed to wind me up.

When you're pregnant, as much as you do or don't want to admit it, you are dependant on the support around you. It's very hard to do it completely by yourself, and if you are on your own, you need to pay people to help you because you need help. That vulnerability, for strong, smart, accomplished women, is not something that's talked about that much. A pregnant woman is going through profound changes. She has the simultaneous ability to be more powerful than she's ever been and more vulnerable than she's ever been. She's going through this event in her life where she is both of those things, and this society does not support that. We almost prey on pregnant and postpartum women in the way we treat them. We sell them a product or a test for everything, but we give them very little information to actually empower or support them.

When I decided to leave my OB, a few friends gave me some information while I was looking for a new provider and it really opened

Erica, Francesca, and Christopher Do Chores

92

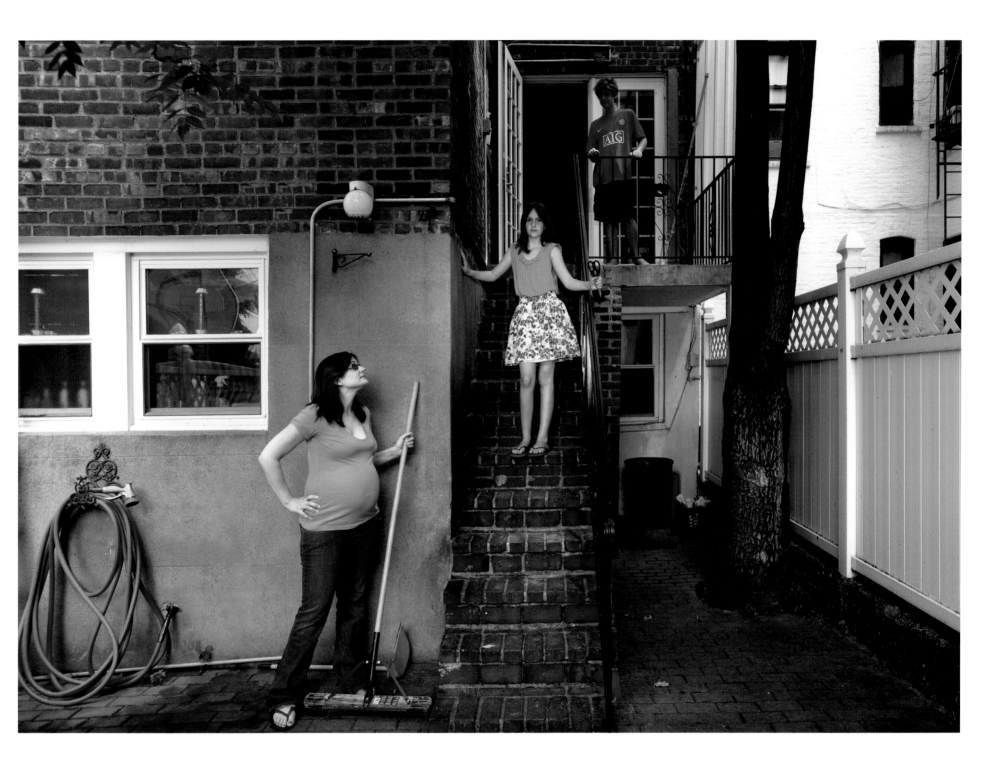

my eyes. There was all this important information right below the surface, and I was lucky enough to have access to it. I felt strongly that it should be available to all women. That's why I became a childbirth educator.

I started working at the infamous Elizabeth Seton Childbearing Center, and stayed there until it closed in 2003 because of the astronomical cost of malpractice insurance. Suddenly unemployed, I did the craziest thing possible. I was a single mom with a three-year-old and an eight-year-old, and I took all my savings and signed a lease and jumped off a cliff and opened Real Birth, my own childbirth education center. Within three years we were a stable business. Within four, we were thriving.

I really feel that the postpartum period and the steps into motherhood are meant to expand us. We know that we build new neurotransmitters in our brains and become better multitaskers in that postpartum period. One's anxiety and feelings of being out of control are also naturally going to increase. We often tighten up in response to how out-of-control it feels. You have to come to terms with that core twelve-step process—that there are certain things we can control and certain things we cannot.

What I realized through this whole process is that it has really been about me developing different parts of myself. When we make that transition into motherhood, we forget that we don't have to show our children just the part of us that is the mom. They need to see the whole of us. That's healthy. For me, motherhood and my business became an opportunity to continue to fully develop who I am. ✧

WE NEED PEOPLE TO HELP US WHEN WE'RE PREGNANT,

END OF STORY.

PATRINA FELTS I AM THE AFRICAN-AMERICAN ADOPTIVE MOM OF TWO SONS—
ONE CAUCASIAN AND THE OTHER AFRICAN AMERICAN. I AM TRYING TO RAISE
THEM EQUALLY IN A WORLD FULL OF INEQUALITY.

As a foster mother for years, I've watched many children come and go from my home.

Nathaniel, who is white, came to me when he was a little over a year old. I was living in Maine and it was assumed he was going to return home to his mom, until she asked me to adopt him out of the blue. It was never in the plan, and at first I declined because I didn't think she'd given it enough thought. But after speaking with her numerous times, I believed her when she said that she'd rather be a teenager and know that he was okay rather than have to struggle to take care of a baby. He has no recollection of her, so there is no suffering from rejection yet, though I'm sure that will happen eventually.

Shockingly, a caseworker from the foster-care placement agency at the time said to me, "How dare you come here and think you are going to adopt a healthy white child. We have couples that have been waiting for years for a child to adopt. It won't happen. "She immediately launched a bogus investigation against me in which she accused me of beating my kids, confining them to their highchairs for hours at a time, and sending them to school dirty. She accused me of a ton of stuff that

I'd rather forget now. Of course the state is mandated to investigate, and they tore my life apart for half a year. In the end it became clear that all her accusations were unfounded.

Nathaniel is five now and we have a great relationship. He has yet to recognize the color difference between us, though we get lots of stares and questions from other people and I often get treated like the babysitter rather than his mother. Once, I was told by the school system that I'd have to come back another time because "only his mother can register him for school." I've often had people in authority check "guardian" instead of "mother" on legal forms on my behalf. Things like that are always happening.

Even my family has a hard time calling him "white." They say they don't want him to feel different. I say he is different—call it what it is. Don't hide the differences. Celebrate them.

I love the age that he is because no child questions that he's my son. Sometimes I wish the adults had the brilliance of children.

Benjamin is seven. He is the fifth child of my first cousin. I remember when my cousin was pregnant with him, she told me flat out that

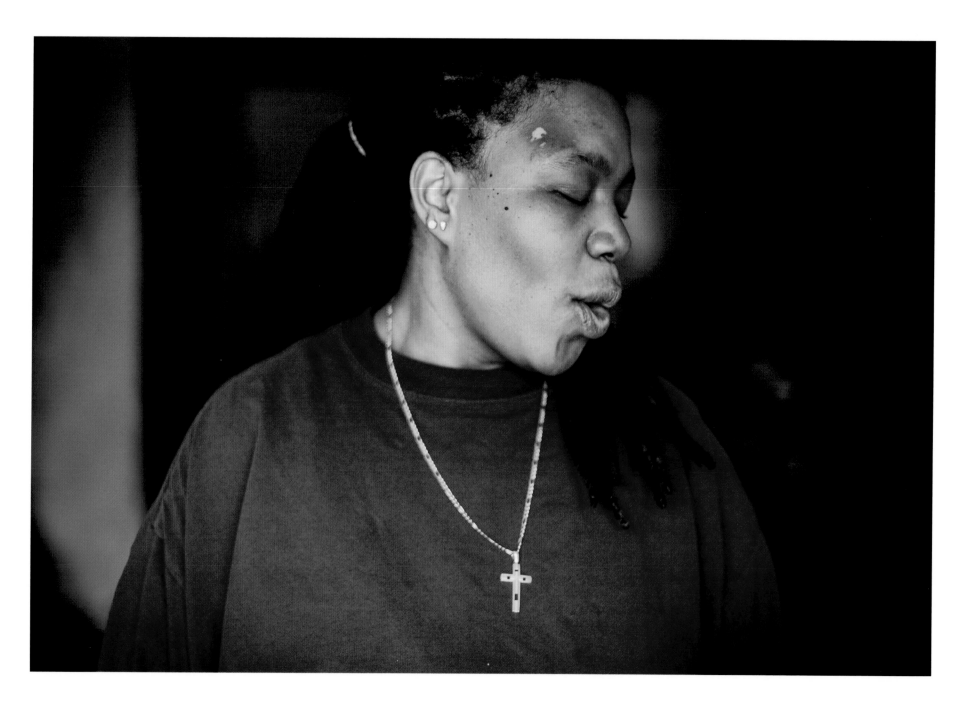

Patrina with Her Cross

she didn't want him and she did everything in her power to make sure that he wouldn't survive. She did all sorts of drugs, drank alcohol daily, had no prenatal care. But he's here and he's very bright. He's had some struggles but as he gets older, it's like the lights are coming on.

I was supposed to bring him home when he was born but he had some issues after birth, so he was placed in foster care with a woman who had been specially trained to take care of his health issues. It took three years of fighting against some of my family members to have him placed with me. They thought that placing the baby with another family would be better. I disagreed.

As a single working mom, I'm blessed with great employers and an awesome support system. When I work, my children are in school. If I need a babysitter, I have my grandmother, my sister, and a great system of friends. Still, I know where we live is rough. I've recently taken in thirteen-year-old twin boys as well. Their mother has been struggling with addiction for years and it looks like I will soon be legally adopting them, too. They're just at that age where either I'm going to get them or the streets will. I know that same challenge is going to come up for my two younger boys too, so we're going to move to a less urban area—somewhere near family but away from the pressures of the street. We'll start over and hopefully things will be calmer for them.

I often think about the fact that I'm raising one child who was born with something called "white privilege" (which some people choose to think doesn't exist, but it does) and one who wasn't. I have one child who may be stopped sometime in his life due to racial profiling and one who will not; one child who may be offered a higher salary for a position than his brother will. I am not looking forward to the day that my son Nathaniel discovers the meaning of the word nigger and uses it against his brother (even jokingly). I am working hard to raise my sons within diverse surroundings, but I am not blind to the fact that one day Nathaniel will realize that we are very different. I am hoping that I am raising a child that will not care.

I know that there are children out there who yearn for someone to love them. If I can help provide love and security for a child who has no one, then my living is not in vain. ✧

Nathaniel, Patrina, and Benjamin at the Front Door

98

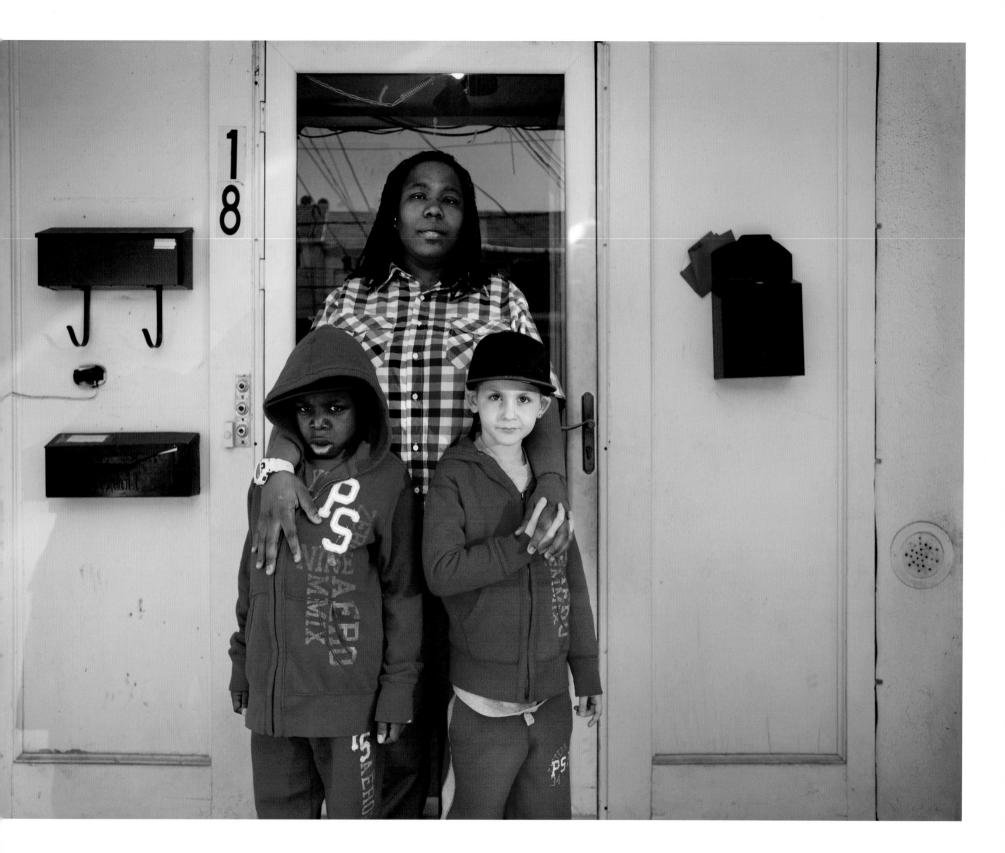

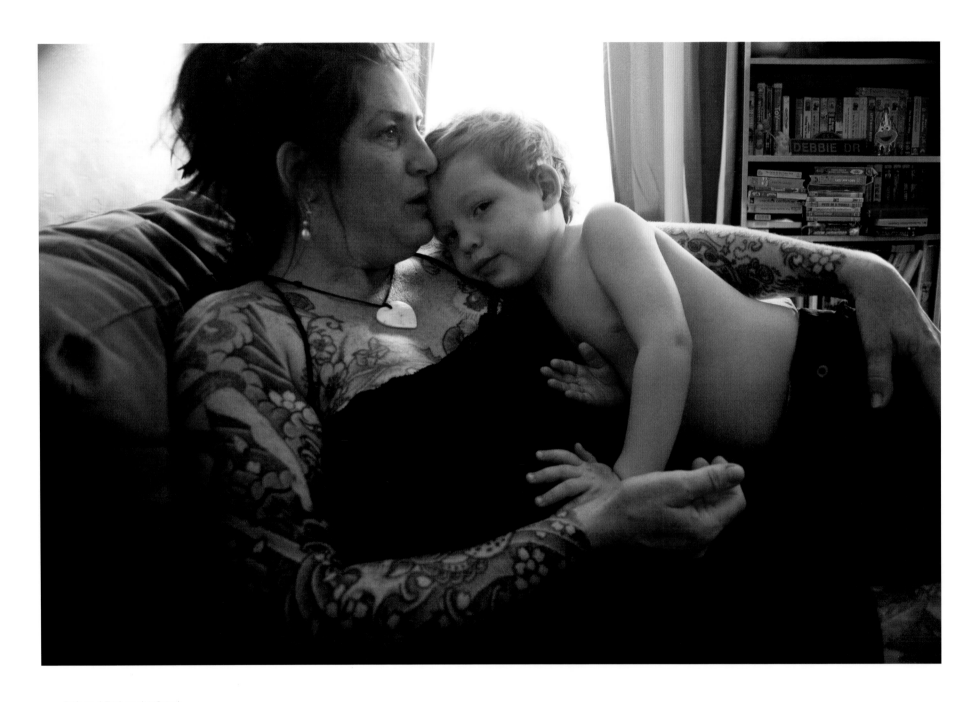

Deb and Earl on the Couch

DEB PARKER HOW MANY YEARS I DREADED, FEARED, ABORTED ANY PREGNANCY.

There was always a good reason not to have a kid and then suddenly there wasn't—and there were five EPT sticks on my kitchen table goading me on to the next chapter in my herstory.

Ninety percent of my girlfriends are childless, and either resigned or comfortable or confirmed in that status. For whatever reasons, it just wasn't in the cards or the sexuality pool they played within. Only one of my lesbian friends has adopted.

I don't think women need one more thing to have dangled in front of them that is the "ultimate experience" for a woman, the one and only truly life-changing thing they can go through. Motherhood isn't that. Or maybe it is that. It can be that.

That said, I do think that it is helpful, for a full life, to have kids and old folks and animals and plants and all sorts of living and dying and breathing and beautiful elements in one's life. They enrich and ultimately give more than they take.

I've always sought out the advice of the very old, and I like the silliness of the very young. The tykes and the geriatrics are similar in that they don't really give a damn. Either they've yet to see it all, so they are eternally curious and mischievous, or they have seen it all and they are just laughing at the rest of us young'uns who are so desperately trying to figure everything out and prove ourselves.

I feel more than somewhat responsible for making my son Earl into a good person, even though I can clearly see he was born his own person. I know I want to shape a great guy to set forth into this world of wonderful women to be a lover, not a fighter. To be a lovable person, not a creep. To be an open, loving man who is not shut down or fearful of the range of his own emotions as well as those of others.

I feel blessed to have had a healthy baby late in life, but I've done the math and it sucks to know that I will be quite old while he is still young. But none of us ever knows how much time we have together, so I just hope and pray for the best. The rest is just the luck of the draw. In the meantime, I love him more than any man I ever gave my heart to. ✦

LUANN BILLETT I NEVER IMAGINED MY HUSBAND WOULD LEAVE US FOREVER.

I married the first boy I ever kissed. He was the first and only one I wanted to be with from that passionate, middle-school moment until our final goodbye. It was the fairy tale that is promised to every young girl, generation after generation. I was completely unprepared for the chain of events that began when we were told I was pregnant with triplets.

My husband immediately started to disappear, leaving me alone to begin a life with my attention, energy, and love in constant demand. I was scared, confused, and angry. But most of all, I was lonely in this experience that was meant to be shared.

It was as far from the fairy tale as possible and made no sense. This was not the man I'd known since we were fifteen. The strong, handsome, smart, and talented person was disappearing more and more each day: the man who'd saved the blanket we were sitting on the night we first kissed, the professional chef who made my favorite meals at home and made me feel like the luckiest girl on the planet, the man I had loved for most of my life. That man was gone and replaced with a different one. This man was distant and angry. This man was cold.

I kept hoping that it was just his fear of the unknown that was creating the problem and that the delivery of our three miracle children would snap him out of it. But while the birth of our children was the most beautiful day of my life, things went from bad to worse for him. In many ways, that's the day I became a single mother.

What I didn't yet know was that over the course of the previous year, my husband had secretly been developing an addiction to crack cocaine.

One morning three months after the birth, after yet another evening of being left alone with three newborns to get up and feed every hour, I dragged myself out of bed. Feeling like the crazy, sleep-deprived woman I had turned into, I angrily stomped downstairs to confront him on the couch, where he'd been sleeping for weeks, to beg for help with the morning routine. By the time I found him, he'd apparently been dead for hours.

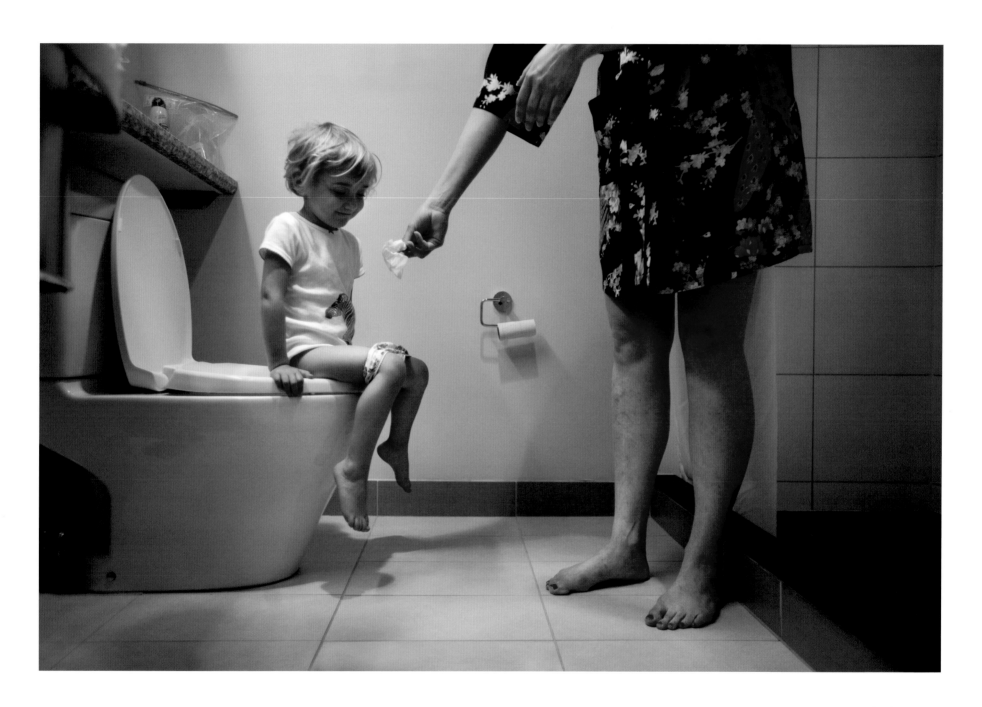

Luann Helps Gabby

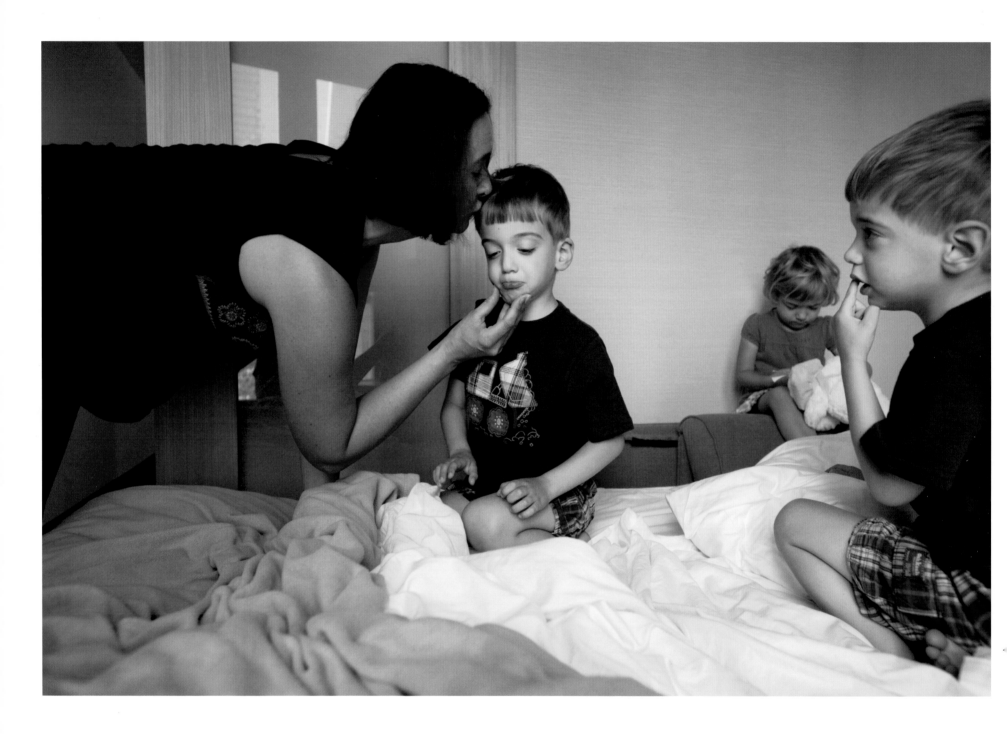

Luann Kisses Anthony on the Bed

I never imagined he would leave us forever.

I do get angry with him for leaving, but mostly I feel terrible for him. He is missing out on the most happiness he ever could have known. He is missing out on three of the funniest, sweetest, and most incredible children on the planet. He was never able to know the joy of seeing a child he co-created thrive, every single day. There were glimmers, before he died, that he could have been a devoted and loving father. While I can hold on to those glimmers, my children can only hold on to narrated, secondhand memories.

After Chris died, I lived in a state of functional shock for two years, concentrating only on the needs of my three babies. We were absolutely blessed to receive constant help and support in the form of free baby-sitting and donations of goods and food from a community of people, including family and friends. In fact, I received so much help that I began to suffer terrible guilt about it and resented feeling so needy. I also began to understand how a mother can put away pride and many other parts of her former self for the sake of her children. I used to be a person who never asked for help and tried to do everything on her own. When I realized that raising my children in the most beneficial way meant allowing others to help, I accepted the assistance gratefully.

Those tiny babies are now four. The result of being raised by a single mother as well as a village of loving family and friends is that they are three of the happiest people I've ever met. They don't have any recollection of their father, but ask about him often. I tell them about the good things, which include his talents and passions. And I keep photos of him up in the house.

Two years ago, a wonderful man came into my life who has embraced all of us fully, which is the only way a man could come into our lives. We're a package deal, and a good one, I think. Recently, we were married.

I know firsthand that it is possible for a single mother to raise her children well, but I have to admit I really welcome the emotional support and connection to a partner in a shared experience. I feel less lonely. I know we would have been okay either way, but Craig has helped elevate the everyday to a place where every challenge, triumph, decision, and dream is informed by a sense of family and love. I'll appreciate it for as long as it lasts, knowing that my children and I will always have each other, and that we know how to thrive together. ✧

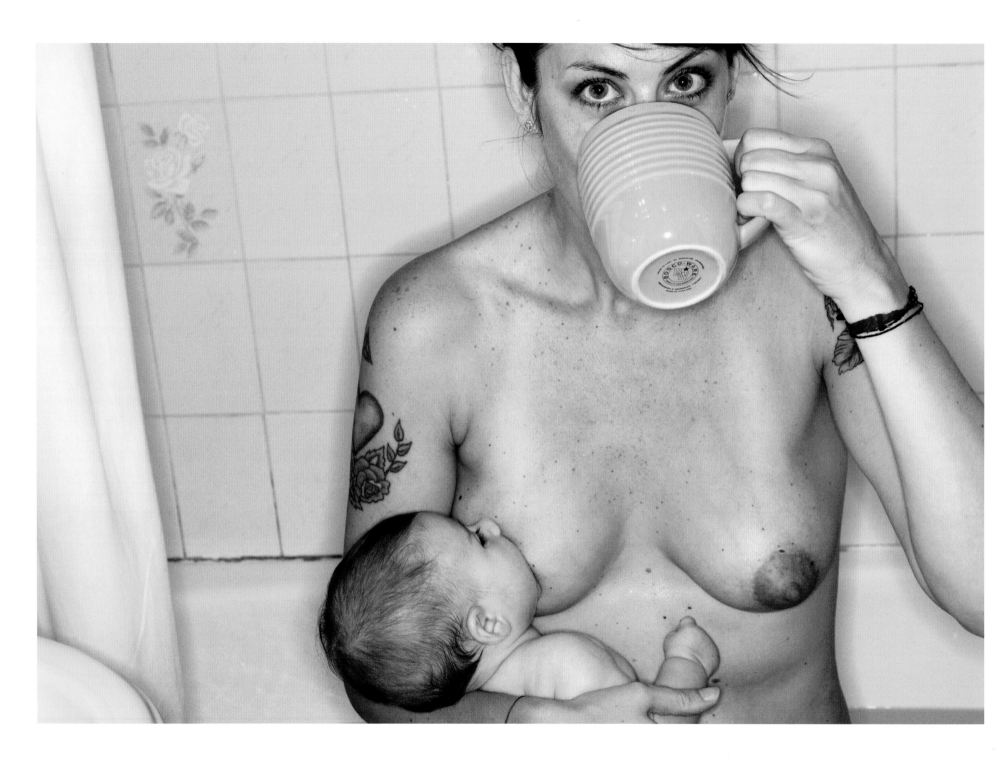

SHANNON O'KELLY WHITE I'M SUCH A SEXUAL PERSON, ALWAYS HAVE BEEN—

but my husband and I didn't have sex more than twice between the time I found out I was pregnant with my first child and when she turned seven months old. You do the math. Marco and I would go back and forth caring about our lack of a sex life. We were both okay with it, but then we'd miss it, but we wouldn't try to have it. It was odd.

Physically, I felt so gross after Billie Jo's birth that I couldn't get in the mood to make "sexy time," and psychologically, I think I was a little traumatized. It hurt like a bitch the first time we had sex after the birth and I was terrified to try it again. Also, I had more body odor and was convinced I was gross and I didn't want Marco to find out.

I'd wear PJs all day, except when I left the house. The second I was back home, I'd throw on the comfy clothes. I'd be schlepping a kid around who'd spit up on me and I'd have to breastfeed every couple of hours. I just wasn't comfortable in my tight jeans. My wardrobe got more and more limited once I was bigger and I refused to commit to my size by buying a lot of bigger clothes. All this didn't help make me feel sexy. Plus, my husband worked till midnight or later most nights and I'd be in bed by the time he got home, exhausted from frantically doing nothing all day.

We decided to have another child, and our son was born when Billie Jo was two-and-a-half years old. We'd still only had sex seven times since we found out we were pregnant with our first child! This time around, we did not even have sex once while I was pregnant, and I was insanely horny and resentful.

My husband is just one of those guys who does not want to have sex with his pregnant wife. I tried not to take it personally, but it was hard. Our situation was very stressful and difficult. We left New York and moved in with family members, one of whom was slowly dying. Our business had failed and we were seriously in debt. Marco was depressed and probably emasculated. The blame definitely isn't all on him. If I'm not feeling desirable or clean, if I'm tired and all touched out from nursing, mommying, et cetera, then I don't want to make love.

At the end of my second pregnancy my husband and I had some really good "heavy, deep, and reals" about our sex issues, fantasies, insecurities, and desires. For the first time, we really got honest. Ever since, my husband has been extraordinarily turned on by me, romantic, affectionate, and most of all, patient—since now it's my sexual appetite that seems to be on hiatus for the time being. We live in our own place that we love, and though we are broke, we are so happy! We've had sex twice since Nico was born four months ago and it didn't hurt like it did after Billie Jo's birth.

I'm taking the time to take care of myself more and I look good and feel good about myself. I used to feel guilty, like any time spent on myself was time that wasn't shared with my daughter, and I'm so glad I've finally gotten some clarity on that! We are closer and happier than ever and I'm filled with adoration seeing my husband and children together. ✧

Shannon with Billie Jo and Coffee

DEBORAH COPAKEN KOGAN I THINK ONE'S DESIRE FOR
CHILDREN FLOURISHES AFTER A BRUSH WITH MORTALITY.

I spent the early part of my twenties as a war photographer, on a first-name basis with death. My reaction to that experience was to try to exorcise it with new life. Because I've chosen to take on the responsibilities of parenthood, I have to choose artistic endeavors and risks that don't conflict with that choice. Before the Iraq war began, I was given a magazine assignment to go to Baghdad and live with a typical Iraqi family; a fabulous opportunity for a journalist, but a terrible choice for a parent, which I chose to turn down.

That doesn't mean I think other war journalists (male or female) with children are wrong or bad, or that I think I'm a better person for my choices. It just means I believe in choice. In all realms.

Even when you don't "go to the war," sometimes the war comes to you. The first words out of my then four-year-old daughter's mouth as we watched the Twin Towers collapse from our living-room window was, "Who's going to take care of all the kids of the mommies and daddies who are dying in that building?"

A different kind of war came to me last year when my youngest, then four, was struck with Kawasaki Disease, a sometimes fatal auto-immune disorder that is the leading cause of heart attacks in children under the age of five. He's now fine, but our bank account, even with our allegedly good health insurance from my husband's job, was decimated.

I breastfed all three of my kids, and I weaned one way too abruptly when my then TV-producer job forced me to fly to Europe for a story while I was still on maternity leave. That was fifteen years ago, and I'm still pained about it. When I came home, my then six-month-old baby had learned to go into my underwear drawer to wear my bra around her neck like a necklace.

Like many women, I've often felt judged in various areas of life, including motherhood. I've been publicly excoriated, by men and women alike, for, in no particular order: being a slut; giving up being a slut; being a stay-at-home mother; being a working mother; being a war photographer; giving up being a war photographer; taking too

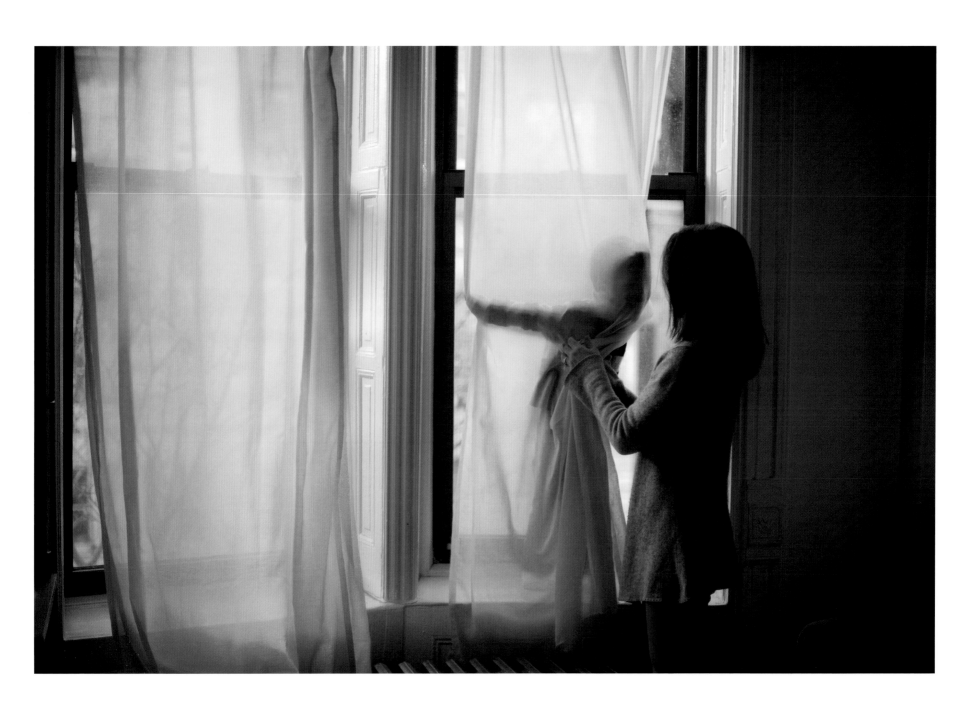

Deborah with Leo at the Window

many risks; throwing away an adventurous life to become (the horror!) a mother; breastfeeding; weaning; being a suburban mom; raising my kids in the city; and other contradictory affronts too numerous and absurd to mention.

I've been a mother now for seventeen years, with three children who span the ages from kindergarten to applying-to-colleges. If there's one thing I've learned in those nearly two decades of parenting, it's that America does not make it easy on families. No mandated paid maternity leave or government-subsidized daycare; no monetary incentives that our fathers take off time when a baby is born, like in Norway.

Is it any wonder we mommas are frustrated?

Like many American mothers, I love my children and have a career and struggle to make it all work in a country that still doesn't get it.

Artificially pitted thus, we take it out on one another, Tiger Mom versus Attached Parenting Mom, working mother versus stay-at-home mother. What an absurd waste of time, column inches, and energy.

My daughter is now fifteen. In all likelihood, approximately fifteen years from now, if not earlier, she'll be having children of her own. I hope it will be easier for her to bring up those children from birth to college age than it has been for me and my generation of women. I hope it's easier on my now seventeen-year-old and six-year-old sons to be involved as fathers in the future, whether through mandated paternity leaves or transforming societal norms about what time it's okay to leave an office. ✧

THE SELFISH PART OF ME HAD TO DIE A LITTLE BIT

FOR THE NURTURING PART TO BE ABLE TO BLOSSOM.

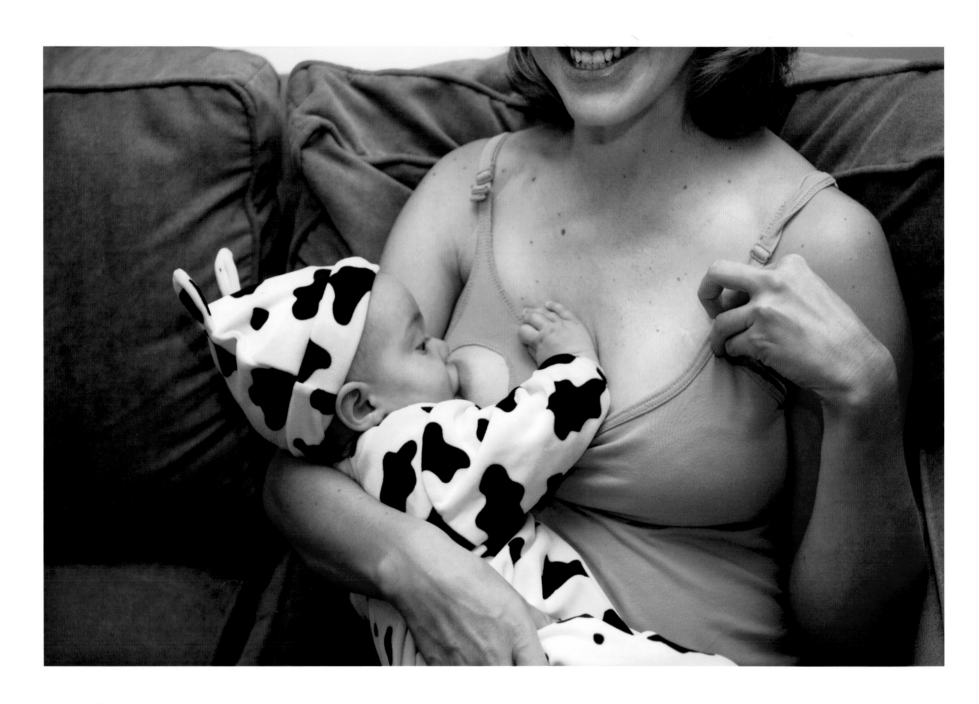

Sophie Feeds Lea

SOPHIE CURRIER DURING A MEDICAL RESIDENCY IS ONE OF THE WORST TIMES TO HAVE KIDS.

You work eighty hours a week and routinely do thirty-six-hour shifts, pregnant or not. It's like a hazing ritual. A lot of women who try to have kids in their first year or two of residency end up on bed rest because they have early contractions. I'd seen a lot of my friends go through this and I didn't want to take that health risk.

You don't really get your first job as a doctor until you're around forty, and I'd seen a lot of women wait until then to have kids. I was nervous that we'd wait and then might not be able to get pregnant. Plus, all our family members were having children, and we wanted ours to grow up with them. My husband and I had been together for eight years and we wanted to start a family. With all that in mind, we decided to get pregnant during my last year of med school, which is very open, with fewer requirements. We thought we had sorted it all out, and figured out a good time when it would have the least impact, but the impact was huge.

In order to become a licensed doctor and accept the great job I had been offered, I needed to pass the National Medical Board Examination test, which is a very long exam. It includes nine hours of actually taking the exam, plus you have to be there a half hour early and sign out afterward, making it almost ten hours at the test center, plus any commuting you have to do. In that period, one should really pump or nurse at least three times. Your body becomes so in tune with your baby that it produces milk according to the baby's feeding needs. If you don't express the milk, you become engorged and it's very painful. The milk ducts can then get clogged and you can get an abscess that needs to be surgically treated, or you can get a bacterial infection that goes back into your system, causing mastitis, which feels like you've got the flu.

The total time allowed for all breaks during the exam is forty-five minutes, an insufficient amount of time in which to breastfeed or pump milk three times, as well as eat and use the toilet.

So I asked The NBME for a slight increase in my break time. Extra break time has been given in the past to people with disabilities, in accordance with the Americans With Disabilities Act (ADA). Breastfeeding is not accommodated by the ADA, although it does cause a change in physiology, just as a broken leg or an enlarged prostate would. What I was actually fighting for was more exhausting conditions under which to take a very difficult test. Being allowed time to pump milk and then rush back to concentrate on a grueling exam is not exactly a luxurious solution.

The NBME suggested their own solution to my dilemma: that I use multiple breast pumps and then just leave everything out after I'd finished pumping and return to take the test, saving cleanup time till

after the exam. That's a solution presented by someone who really has no idea about breastfeeding. First of all, no matter how many pumps I had, I'd still have only two breasts. That's not going to change the process. And second, it wouldn't be sanitary to leave a bunch of pumps and breast milk around.

In the end, Judge Katzman of the Superior Court ruled in a preliminary injunction—an emergency decision—in favor, forcing them to give me an extra hour of break time. However, the NBME fought back with several appeals up until the day before I was supposed to sit for the exam. I walked into the test unclear as to what, if any, accommodations would be provided for me. The pressure of fighting a majorly publicized lawsuit, along with parenting a one-and-a-half-year-old and a newborn, were not conducive to great concentration. I did not pass the test that day, but took it again about a year later, when I was done breastfeeding, and passed with a very high score.

If we choose to be mothers, do we just not become doctors? People ask, "How are you going to be a resident and nurse your child?" First of all, the care of an infant is for a short period of time. Plus, you can work and do this. Some hospitals have daycare centers so you can run down and nurse during shifts. I had no problem being able to pump during my rotations. It wasn't even usually necessary for people to take over, but if they had to, they let me go, because they understood it was important. Usually I'd do it between patients and on my lunch break, and then stay thirty minutes later that day. I saw other women do it, too. If companies and hospitals had daycare, you could run out and nurse and it would take less time than going out to smoke a cigarette. The science is in on the medical benefits to the child of breastfeeding. If the medical community won't support us doing it, who will?

You can do it all, and women are willing to do it all to make everything work, but it does mean we need a change in the infrastructure. We can't stick with the old model because it's based on only men being doctors. Women are now forty to fifty percent of the people coming into the workforce, and at some point many of them are going to have children. And when they do, they're going to be in a different physiological state and they're going to need different conditions. I didn't feel I needed anything different as a woman until I got pregnant. But when you're pregnant or have just given birth, your physiology changes, and sitting for nine hours in a medical exam and not being allowed a proper break to express milk, for instance, or working eighty-hour weeks during your residency, becomes a health risk.

Some people argue that women should just stop working for a couple of years. Well, our society can't afford to have forty percent of the medical population stop for a year or two whenever they have a child, so that's not an acceptable solution. Plus, no man has ever been told he'd have to put his career on hold because he had a child.

In 2007, I filed litigation against the National Board of Medical Examiners because the initial decision by Katzman was just a preliminary one. In 2012, the Supreme Court of Massachusetts ruled that the policy of the NBME discriminates against women and that from now on they must provide appropriate increased break time for breastfeeding women taking the test. This is a landmark case for women's rights and sets an important precedent that breastfeeding is a civil right that must be legally protected. ✧

Sophie and Lea at the Lake

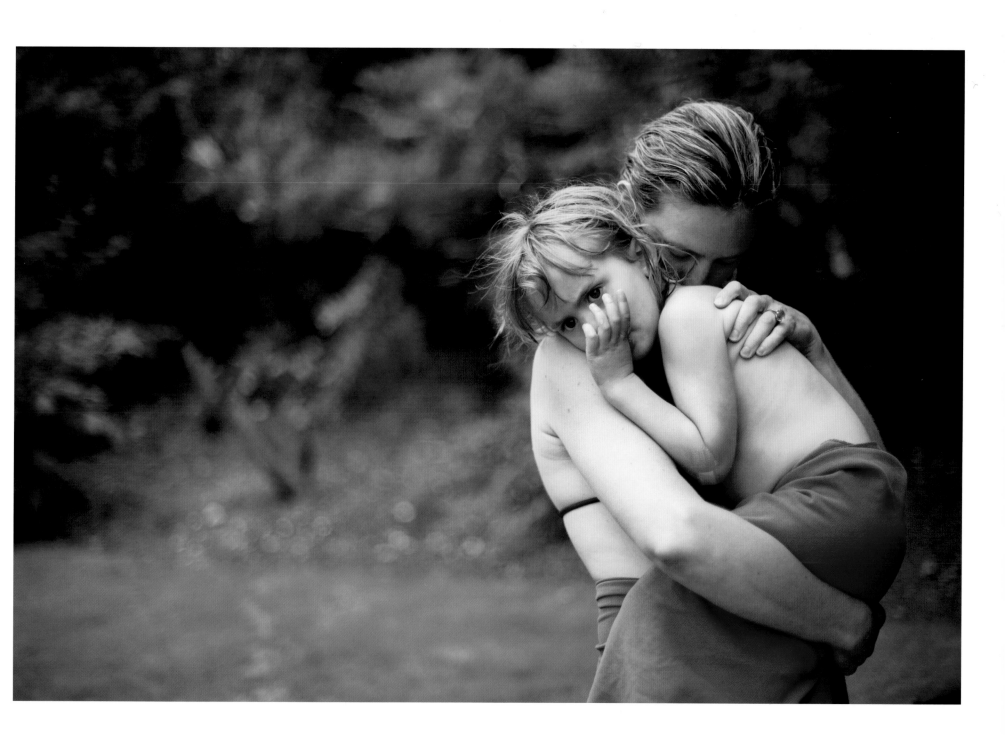

ERIKA DEVRIES LIFE AS A MOTHER IS POLITICAL, SEXY, EXCITING, DEPRESSING, CREATIVELY CHALLENGING, AND DEFINITELY EXHAUSTING.

It is so many things, my thoughts on them change hourly, but it feels very right. I am devouring the experience. I feel like a piranha of life, or some such creature!

I have two sons, Dove and Zane, and we live pretty deep in Brooklyn, in an attic apartment of the house my husband grew up in. Grandma and Poppy are both still alive and live on the floor below us, which offers us a great system of support. The drawback is that my husband and I have to travel quite a distance to get to our jobs.

Before teaching photography at a university, I worked for years taking care of people of all ages, both as a teacher and in a growth-and-activity capacity at a retirement home. Through that work, I saw how important sharing the mundane aspects of everyday life is in order for me to connect with people. I want to devote enough of that sort of time to my children to assure that we connect well. That said, I did make a pre-childbearing arrangement/agreement with my husband that we would be fifty-fifty partners in our parenting responsibilities. Sometimes I'm sixty and he's forty, sometimes he's seventy-five and I'm twenty-five. Occasionally we hit fifty-fifty and enjoy the sweet spot!

We've chosen to keep our lifestyle—in terms of money—modest so that we can both raise, know, be with, and learn from our children. Finan-cially, it is a struggle. Our biggest expenses are that we eat only organic foods and that soon we will have two children in private school. Money will always be a struggle because of the commitment we've made to our educational philosophy for the boys and the choices we've made to both remain artists and teachers. We've tried being other things but they don't fit us well. This is what we are, what makes us happy, what we are really fucking good at, and what makes us feel right in the world.

I hope we will always balance what is good financially for our family with what's good for a daily rhythm and culture for us as well. I feel very lucky to have all that we do. It would be very hard for us to be in New York City without having this housing situation. It would also be emotionally much more difficult if we did not have family so nearby.

It can be difficult for me to see all of the things there are available to the children of people who have money, but really we already have too many things. In our culture it's a blessing to have such trivial troubles. We are really screwing up the world and each other with all of our things, things, things, things, things. Money can buy access and opportunity, which is admittedly huge, but it can't buy anything else in the huge department that children need—i.e., thoughtfulness, security, and love. ✦

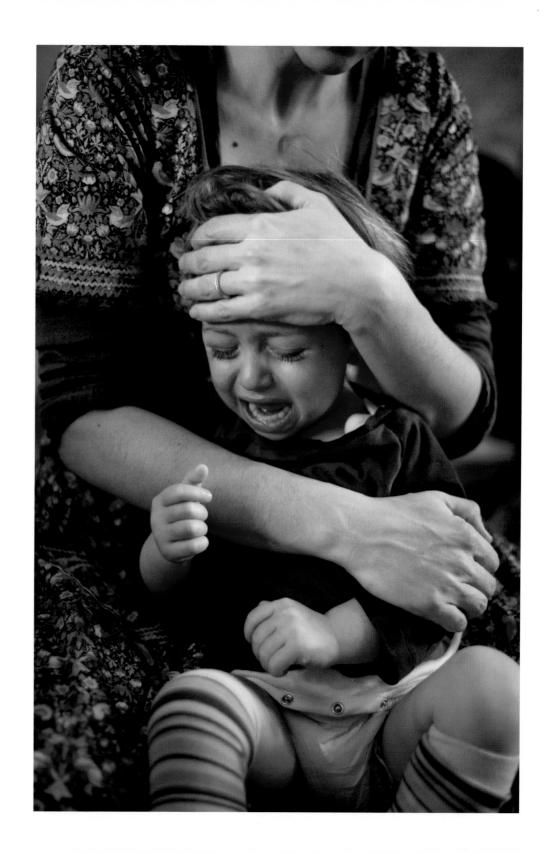

Erika Comforts Zane

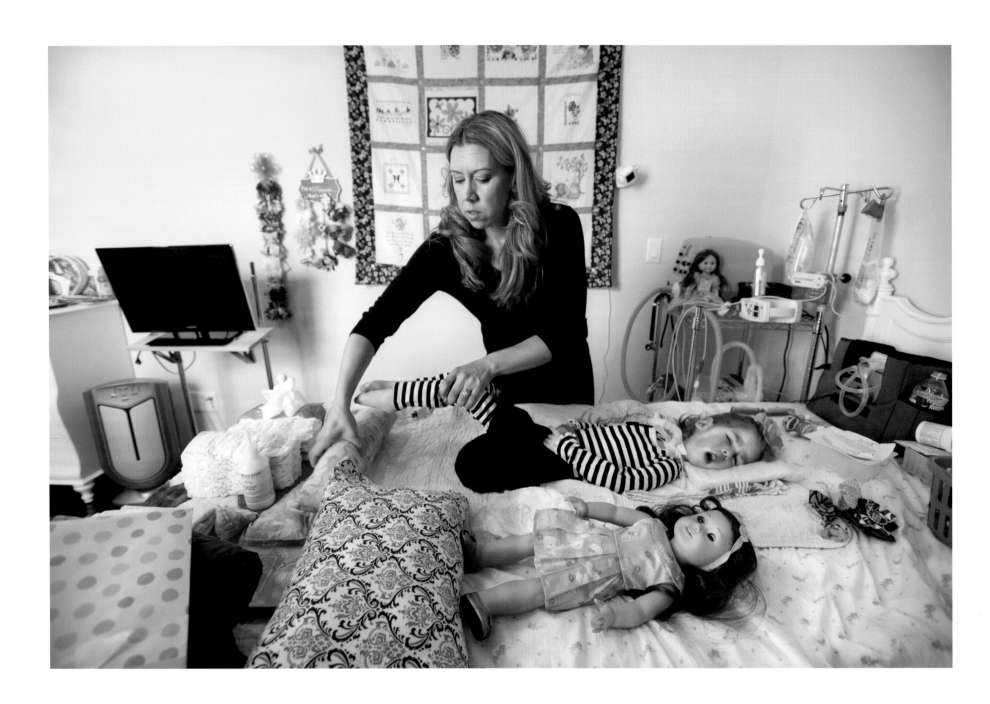

Catherine and Sophia in the Bedroom

CATHERINE GAYNOR ALL I'D EVER WANTED WAS TO HAVE A BABY.

After we got married we tried and tried and it just wasn't working. At one point, I got pregnant and I miscarried. So when we got pregnant with Sophia we were extremely happy and praising God and we were so careful. You think to yourself, "Oh, God, if anything ever happened to her I wouldn't survive." You see these families and their kids have these syndromes or cancer and you think, "I could never go through that. I would die."

And then it happens to you.

Sophia was born with Spinal Muscular Atrophy, Type 1. SMA is a terminal disease. There's no treatment. No cure right now. Your child is born perfectly healthy and then slowly you watch as the disease takes away your baby's ability to breathe, eat, and move around.

It sounds grim and sad and I cry talking about it, but she's the best thing that's ever happened to me and I would never change her for anything. She is the sweetest soul in the whole world and she makes me be a better person. The love that little girl has brought into our lives... she's the reason I'm a mother. I never knew love before my baby. That love...it leaves you speechless. There are no words to describe it. I will always be grateful that I knew that love between a mom and her baby.

The very first time that Sophia crashed was a year ago, during treatment. She was being coughed—something we do three times a day. A machine blows air in, then sucks it out, forcing her to cough. This keeps her lungs clear. It's a little scary, because you might pull something up that's too thick and it can get lodged in the windpipe. On that particular day, that's what happened.

I had coughed her and put the machine down. When I looked back, she was completely blue and her eyes were rolling into the back of her head. I immediately grabbed the cough machine and started coughing her again and saying, "Sophia! Stay with Mommy. Stay with Mommy." Her oxygen was down to ten and her heart rate was down to fifty. They say at fifty you need to start chest compressions. After two sets of coughs, whatever it was suddenly came up and immediately her heart rate and oxygen jumped back up.

Even though Sophia lives with all these machines and I do these

treatments on her every day, I forget how weak and how sick she is. Moments like those bring me back to the reality that I could lose her at any second. That day, I put her back on her breathing machine, and even though she's not very strong she squeezed my finger so tightly. I knew that meant she was afraid and that killed me because I don't ever want her to be afraid. So I sat there all day and held her hand.

On a positive note, at the same horrible moment, I was empowered. I realized I can bring her back and I felt I wouldn't be afraid if it happened again—which it has. I'll always know I can do it. I can bring her back. Now, whenever Sophia crashes, I am very calm and I talk to her and tell her to stay with me and she does. But as soon as it's over, I completely lose it. I'm hysterical.

I don't know if I will outlive my daughter. I will probably lose her before I die. I try not to think about that too much. If that time comes, I will know that we did everything in our power to fight for her. Nothing's for sure. I could go outside tomorrow and get hit by a car. There are no guarantees. We don't know how long any of us has with those we love. I try to think about it that way. The fact that Sophia has been diagnosed with a terminal illness doesn't mean anything. They told us she wouldn't live two years and she just turned three. Obviously she was put here with us to make a difference. She's opening peoples' eyes every day.

I just pray that if she does die, I'm with her and I can hold her and just sing to her and kiss her. And I know my mom will be on the other side waiting to take care of her until I can get there.

I think that's the meaning of life. That we all have to reach that level of love that is so much bigger than ourselves and our own private world. ✧

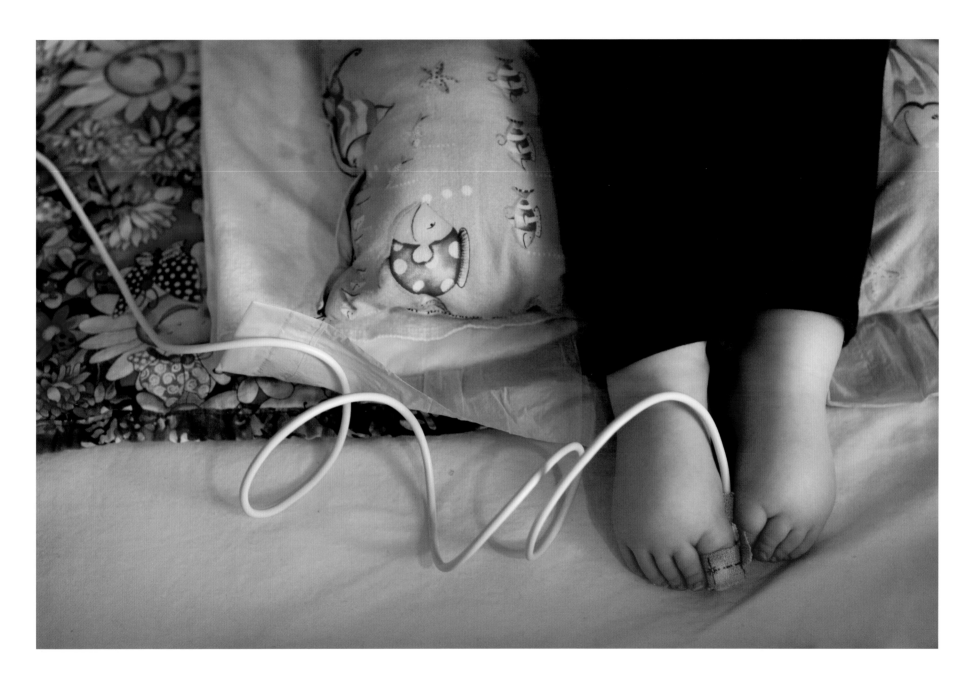

Sophia's Toes

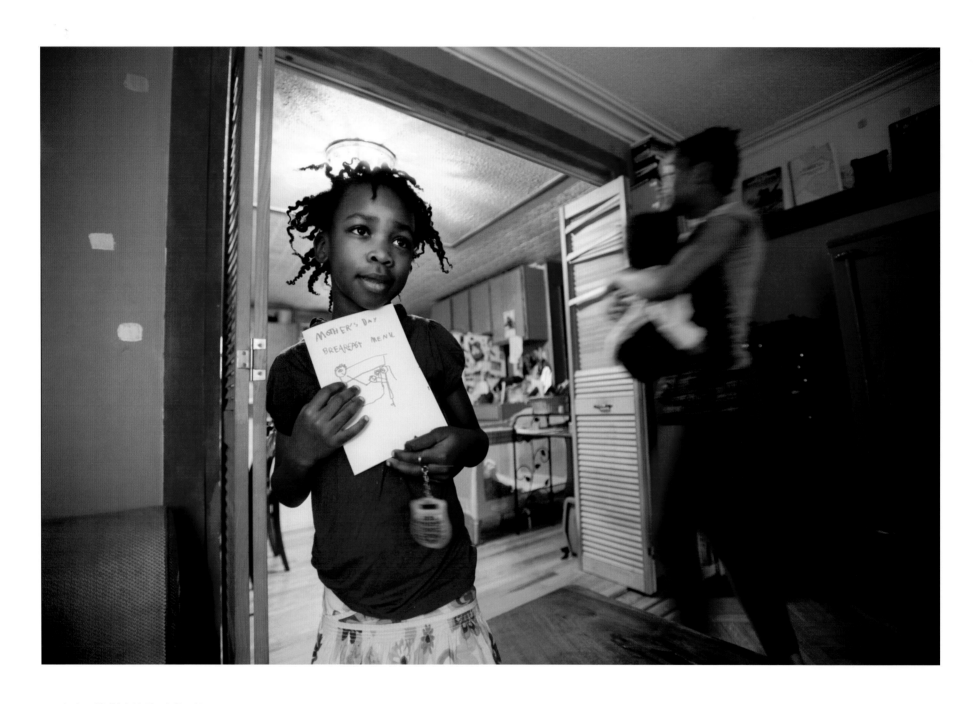

Ixele with Ola's Mother's Day Menu

OLA AKINMOWO ME AND ABOUT FOUR OR FIVE OTHER PARENTS STARTED THE LITTLE MAROONS COOPERATIVE A FEW YEARS AGO, BASED ON THE OLD-SCHOOL IDEA THAT IT TAKES A VILLAGE TO RAISE A CHILD.

We all had children around the same age and we were trying to figure out the best way to have our children in the school system but still take a hands-on approach to how they were being treated as well as what they were learning. So we set up this school on the top floor of a house a friend owns.

Ours was an African-style approach, so as is the custom in Africa, every woman was called a "momma" and every man a "babba." It's a respect thing. While you're in the classroom, your teachers are your parents.

Even though we all saw ourselves as pretty progressive people, there are always hot-button topics, such as sex and discipline, that people have different opinions about handling with kids. That brought up interesting conversations, but never conflict—always discussion—because everyone was very open to new ideas. We actually took a full-day retreat where we discussed everything about the school and what we wanted from our children's education.

The demographic of the group is working-class, slightly struggling Brooklyn parents. Everyone was working, hustling all the time, so the cooperative was a lifesaver for us. Outside of the children having somewhere to go from eight o'clock to six o'clock, there was a lot of trading of babysitting which was great, especially for the single mothers who had to work two or more jobs, like me.

The more you worked at the co-op yourself, the less you paid; so if you worked enough days, your child could go there for very little money. We decided there would be one main teacher who was at the school every day, Monday through Friday, and that would be me. It was also decided by the group that I should get paid a salary. It wasn't a lot of money, but it was enough for me to survive on; I couldn't have com-

mitted to it if I hadn't been paid. Everyone thought I was the natural choice because I grew up around a lot of children and was the one who always took care of other peoples' children. Friends call me things like "the 'hood Mother Goose."

In the summer, we started the Little Maroons summer camp at my house. So the kids have developed a little crew, which gives them a lot of confidence, and the parents have a supportive community.

The mothers were the first ones to organize. Once the ball was rolling, the men got more involved and there were a couple of fathers who created a strong male presence. That was really inspiring for me. It made me feel strongly that both genders need their fathers in order to gain exposure to a different perspective and way of thinking. I think it's important for men to be involved with the children they helped bring into this world. First of all, I mean, you helped create this child, you've got to be down for what's happening. But also, it's too much for one parent to have all the responsibility for teaching the child everything about how to be an adult. The kids who were being raised by mothers only were especially attentive when there was a babba in the room.

I had to put my own aspirations on hold to mother Ixeles well, and unfortunately it did feel like a sacrifice. Even my mentor—this woman who clearly had her own issues and maybe some guilt about the fact that she hadn't been a very hands-on parent—told me it was the end for me and my goals. That depressed me so much. But I'm not afraid of hard work and I feel that I can still pursue my dreams. Next year, I'm going back to school to get my MFA. ✧

WHEN I HAD MY CHILD, LOTS OF PEOPLE TOLD ME THAT

I'D NEVER BE ABLE TO PURSUE MY PERSONAL DREAMS.

WENDY KAGAN I LIVE IN ONE OF THE MOST PROGRESSIVE COMMUNITIES IN THE WORLD: WOODSTOCK, NEW YORK.

Alternative lifestyles are the norm here. But when it comes to gender roles, they're pretty much the same in Woodstock as anywhere else in the world. With surprisingly few exceptions, moms take care of the kids and dads bring home the bacon. Sure, a lot of mothers do work. Many send their kids to daycare for a time; but when they get home they remain the primary caregivers and dads play more of a supporting role.

In my house, it's different. My husband Michael and I are freelance writers, so for the most part we can make our own schedules. After our daughter Amelie was born, we created a style of parenting that I call "pass the baby," alternating between working and parenting in shifts. There are advantages and drawbacks, but the advantages win out by a long shot. We divide all of our work—home and otherwise—equally. Even our paychecks get made out to both of us. That means the one doing housework and childcare at any given moment is getting paid the

same as the one working at the office.

It can get a little hectic sometimes, but it works out. We have our slots. Michael is an early riser, so he works from five to eight, when everything is quiet. Then Amelie gets up and I go get her and we start our day. After breakfast I pass the baby to Michael, and from about nine to noon I have my solid work hours. After we all break for lunch, Michael works from one to three, and then I have from three to five and a little bit beyond. Whoever is on a tight deadline can get a little more time, but it's pretty regimented. It has to be, or else time can just slip through your fingers and the day is gone. We used to wing it, but that wasn't working at all and would just lead to fights.

Michael sometimes feels like the odd man out on the playground or at library story hour, where he's often the lone dad. When I was pregnant he started looking for books about fatherhood, but the pickings

Wendy Fixes Amelie

were slim. There were many great books for expectant mothers, but the books for dads were jokey and often downright patronizing. They were perpetuating the notion that fathers are generally clueless oafs who don't actually have to learn to do very much since the mother will do it anyway—and do it better. He finally found one good book with a sidebar called "Diapers 101" and he was so excited. It was written by a stay-at-home dad and it ended up being a great and inspirational resource for him.

I feel like there are a lot of supermoms now who take on everything. I've known families in which it really seems like the woman is holding it all together. You just want to shake the husbands and say, "Hey, wake up! Either make more money and contribute, or take on more of the childcare. Do your part."

Modern feminism doesn't address the issues of childcare and motherhood all that well. In my women's studies classes in college, I can recall a mention or two of state-supported childcare, but that was about it. There just aren't very many solutions to the problem of juggling work and family. The feminist movement has been much more vocal about getting women equal treatment in the work world. But there's this whole other realm of home life that's just as important. Thankfully, I have a husband who is very liberated when it comes to gender roles. We've just had to be creative and come up with our own solutions. ✦

FOR THE NEW YEAR, WE CAME UP WITH A MANIFESTO: WE REFUSE TO BELIEVE THAT A LIFE OF ADVENTURE IS INCOMPATIBLE WITH A LIFE WITH KIDS. WE WON'T STOP GROWING AFTER BRINGING KIDS INTO THIS WORLD. IN FACT WE OWE IT TO THEM TO KEEP EXPANDING OUR LIVES AND MOVING TOWARD OUR DREAMS. EQUALLY SHARED PARENTING SHALL BE THE NEW WORLD ORDER.

MAGGIE CRAWFORD ONE MORNING MY THREE DAUGHTERS AND I WERE ATTEMPTING TO WALK THROUGH THE SNOW AND PATCHES OF ICE TO GET TO THE TRAIN FOR SCHOOL.

This daily, fifteen-minute trek starts to get really old by the end of January. My oldest child, who has Asperger syndrome, was in complete awe and harmony with the falling flakes. Chloe is almost eleven, tall and beautiful, with swishing brown curls. Suddenly she stopped and dropped to make a snow angel, and my youngest daughter, Hannah, followed her lead. Meanwhile, Esther, my middle child, was completely in synch with me, hustling to the train so we wouldn't be late. I was so frustrated and tense that my jaw hurt from the set of my mouth, and my shoulders were up to my ears. We passed a huge clock that revealed just how late we were—them for school, and me for work—and soon I was shaking with anxiety and anger.

So much had been leading up to my lack of tolerance at that moment: my husband not being employed for well over a year, his unpredictable health issues, running out of money well before each paycheck, and my children—who have cavities—not having been to the dentist for almost two years. My husband was away in Detroit looking for a job and I had been having chest pains for a week due to anxiety.

When we finally got on the train, I was still shaking and began massaging my jaw. We were so late, and the train was crammed, causing me to whack into people with my daughter's cello that was strapped on my back. I was a sweaty, anxious mess.

Then, quietly, Chloe, who was facing me, smooshed up close and started to chant in her monotone voice, "Peace and relaxation, Mom. You are going to be okay... everything is really okay. Patience, Mom. Breathe deep..." Over and over, she chanted her incantations and prayers over me with her usual blank expression and those wide, dreamy eyes.

She leaned forward to kiss me with her slobbery mouth and I was drawn instantly into a new feeling. Rather than resentment, I felt ashamed. Ashamed that my child was parenting me. My dear, magical child, whom I worry over so often, was mothering me today. And I felt helpless.

Some passengers moved apart so that little Hannah could join us. She reached between the cello and my coat to rub my back and another wave of grief came over me, tightening my throat. Esther smiled at me, peeking over her Harry Potter book. And there we were, swaying with the crowd, Chloe's chanting punctuated by her sloppy, wet kissing and Hannah rubbing my back ceaselessly.

In this moment, I looked at my daughters and I realized that I am so very rich. I hope those nurturing qualities can be renewed in myself again despite my exhaustion and stress. I hope that I can be a healer to my children, but I'm also glad I've given them the tools to be nurturing to others. ✧

Maggie with Hannah in the Kitchen

CHRISTINE AND JACLYN VARGO JACKIE WAS THE FIRST TO REALLY WANT KIDS, BUT BOTH OF US WANTED TO BE MOTHERS.

Chris: It involved a little bit of science for us, so we educated ourselves about the options and found a community of like minded, same-sex couples who became a support network for us.

Jackie carried our first daughter. It took seven Intrauterine Inseminations (IUI). When we found out we were expecting twins, we were thrilled. But soon after, at ten weeks, we lost one heartbeat. We were devastated. Isadora is our surviving twin.

The first time I held Isadora in my arms I felt, "This is my baby. I would take a bullet for this child." I don't see how other mothers can't understand that you can absolutely be a mother even if you didn't carry that baby in your uterus.

Jackie: The moment you find out you're going to have a baby, you make a space in your heart. That's why a miscarriage hurts so much. That space is already there. That space is filled with expectations and dreams and hopes.

Chris is a surviving twin, just like Isadora. Women don't discuss these losses openly often. We're so afraid to be seen as failures, especially when it comes to motherhood, something that's supposed to be natural for us. We're afraid of being judged as having failed at pregnancy.

Chris is carrying our second child and is currently thirty-four weeks along.

For this pregnancy, Chris went through six IUI's that didn't work. We then decided to try a round of in vitro fertilization (IVF), where they remove a number of eggs from the mother, fertilize them, and then transfer them back into the mother's uterus. It was important to both of us that our children be related by blood, so we used sperm from the same donor we'd used for me. Our supply was finite and dwindling, which was a part of our decision to switch to IVF. While it is more expensive and invasive then IUI, there is a higher success rate. Additionally, we were able to store five embryos for potential future use.

Chris: We have spent a good deal of our savings and held off on contributing to our retirement funds to cover second parent adoption fees and the parts of our fertility treatments that were not covered by insurance. We made the decision to put money into this endeavor rather than, for instance, planning a big wedding ceremony. Instead, we married at City Hall in Greenwich, CT, prior to Isadora's birth.

We knew that starting our family was going to cost us financially and that we were beginning the process essentially as two infertile women in that we lacked access to sperm. We decided that the financial costs were something we could prepare for ahead of time by making choices and sacrifices. The physical and emotional costs were not experiences we could have prepared for. Neither of us could anticipate how long becoming pregnant was going to take or the roller coaster of

Isadora, Jackie, and Chris at the Beach

anticipation, hopefulness, excitement, and then ultimately disappointment we would experience with each attempt. We felt frustrated and disappointed with our bodies, like they were betraying us. The process was stressful and intense. If we hadn't had such a strong foundation as a couple to begin from, we could have very easily drifted apart or given up. Our communication needed to be intentional, mindful and honest. The entire process proved to be both extremely challenging and rewarding, and our relationship is much stronger as a result.

People ask us things like, "Which one of you is the mother and which is the father?" rather than understanding that we are both mothers and that Isadora doesn't have a father. They tend to want to put things into neat boxes and categories, and in a situation like ours, those boxes don't always apply.

Jackie: Now that Chris is pregnant, people say, "You're going to be a great mom," as if she hasn't already been a great mom to Isadora for two-and-a-half years. I feel the same way about the baby in Chris's belly as I do about Isadora, whom I carried.

It's been frustrating and hurtful for me to see how people prioritize the different tiers of motherhood. You are on a higher tier when you are able to carry your own biological baby. My pregnancy with Isadora wouldn't have been possible without Chris by my side every step of the way. I had more than a hundred appointments in order to get pregnant and keep the baby, and Chris was at every single one of them with me. I can't tell you how many women I know who have struggled with fertility who say their male partner only came to their first appointment or when a specimen was needed. There is no replacement for going through that difficult experience together. Sitting across the room from a professional filling you with a tremendous amount of information. Going through the treatments. Having invasive procedures and dealing with the disappointment when they don't take. Chris was with me every moment. And that is part of the process that made us both mothers to Isadora.

Chris: We will always be honest and open with Isadora about the fact that she doesn't have a father. It was important to us that our donor be an open and anonymous one. That means that when our children turn eighteen, they'll be able to look him up and find out more about him, his history and background. We don't ever want to keep our children from knowing more about who they are. Isadora knows that kids in her daycare have fathers and she doesn't. It's a bit early, at two-and-a-half, for her to articulate what that means, but I think it will be her norm to have two moms. We'll just have to pay attention to how she reacts as she gets older. We'll always let her know that there are a lot of different ways to make a family.

Jackie: In every family there are differences. Some surprise people and some don't. The Huxtables normalized upper-middle-class African American families for the average person. I don't know if most people see a same-sex couple with a family as normal yet. People feel the right to comment on the difference of a family with same-sex parents. And perhaps they will, until it doesn't seem so different any more. And then the focus will be on some other difference.

Chris: I think there is a lot to be said for anyone who is open enough to hear a different perspective and take it in on some level. And not be too quick to judge. As far as issues that compel me to express my opinion, for me it's two women having a child together. In the same

way that sexual violence against women compels me to speak up, I don't want to lecture people about it; I just want to put my two cents out there.

Jackie: I know there is some mother in Afghanistan right now rocking her child to sleep just like I do. Regardless of our differences in race, religion, or circumstances, she feels the same way about her baby as I do about mine. Motherhood is a great unifier. ✧

Tanya with Jadun and Hunter

TANYA FLY MY KIDS DIDN'T ASK TO BE HERE OR TO HAVE THEIR PARENTS SEPARATE.

Although my children's dad is not my romantic partner, he truly is the most important male in my life because he is their father and that's something that will never change. The possibility of falling in love and having another relationship that could be a part of our family does exist, but not if that person needs our family bond to be broken in order to do so. I wouldn't allow that to happen.

I believe it's important to have a personal life, but when you have children you have to be extremely careful about how much you're willing to give of yourself to another person. If and when I decide I want to build a life with another man down the line, I will slowly begin helping him define his place in the children's lives, making sure that it does not negatively impact the stability I've worked so hard to create with their father. I'm a woman, yes, but I'm also a mother, and ensuring their well-being and a solid sense of their family's foundation, despite their parents not being together, is my ultimate obligation. In the same way that I safeguard their belief in Santa Claus, the tooth fairy, and the Easter Bunny, I want my children to have a time of innocence about their family life. I don't want their family structure to be a fantasy like those other things, but I also don't want the kids to be burdened by our separation.

You want to believe that giving your love, that teaching your kids right from wrong, that imparting your values to them will be enough. All their lives I've taught my children that it's about who they are as people that matters; not how they look, not their race, but who their family is

and how they behave as people. But that's not entirely true, is it? Life will, in some ways, disappoint them. Things will happen to them that are not fair. Because they will soon be young black men, they will at some point be stared at with suspicion on the street. I've also tried to teach them to put one foot in front of the other and, most importantly, to hold on to their core values no matter the circumstances. I want a sense of family to be a part of their core values.

I spent all of last year finally fleshing out the legalities of what my ex and I had been hammering out between ourselves for years, regarding how this family would run. Again, this has been challenging, and I have been jealous at times of my ex-husband's new relationship. I felt I had all the work of raising the boys five days a week, and then on the weekends they got to play house with him and his girlfriend. They got to watch their dad in a happy (my assumption) romantic relationship with someone else while I was dealing with my own feelings of loss largely on my own. Despite my personal feelings, however, I had to learn how to separate what I thought was best for the functionality of our family, which I felt needed to be the constant in their life. To do that, a more fair division of time and labor, and fair economic standards, had to be worked out.

It's been challenging at times to stay focused on the long-term goals of building a better me and a decent life for them, especially when I get lonely. However, I believe I'm becoming the woman, mother, and partner I would ultimately want to be. And that feels really good! ✧

ALICE SHIRES I THINK THERE SHOULD BE AN ADVERTISING CAMPAIGN FOR NEW MOTHERS THAT READS, "JUST GET ON WITH IT!"

In other words, just accept the fact that for about a year, you're going to be tired and feel out of shape and wear dressing gowns a lot and that's okay. Be kind to yourself about it.

I hated looking at adverts as a new mom! I felt insulted by pictures of how you were supposed to look and how you were supposed to have a happy baby who was all pink and round. And how you weren't supposed to be fat and sometimes depressed. It felt insulting to the real experience, which was messy and sometimes lonely...and most of the time, very low key and back-to-basics.

The human mind is a judging one. I recall a lot of judgment when I was pregnant. I joined these mommy groups to find support, but horrified everyone when I admitted I was going to have a planned cesarean. People said the word "cesarean" to me in hushed tones, as if I should be ashamed about it. I didn't really care how I had my children as long as they were safe and healthy. I met all these women who had very specific and elaborate ideas of how they wanted the birth to go, and I thought wow, some of your are going to be really disappointed.

I think that image of motherhood perfection persists because everyone deeply wants to be happy. And if you think you can buy the right toilet roll, for instance, and achieve nirvana, you'll probably do it.

There's a lot of mommy competition. I remember worrying about not having the right stroller, not having breastfed for long enough...a lot of effort went into worrying about a lot of things.

The way a mother feels towards her baby and motherhood is so complicated. I hate to think of any mother suffering under the tyranny of intellectual judgment about her choices on top of the difficulty of the task at hand. I do remember that feeling of terrible envy of other mothers if they seemed to be doing better than me, or if their child was more relaxed than mine. I wondered why I couldn't do things as well as them. Now I just think you do the best that you can.

If everyone suddenly disappeared and you were parenting just to parent, without anyone knowing or judging what you were doing, and without comparing yourself to anyone else, that would be the ideal way to do it. If someone could help you, great. If not, you'd just move on. But that's like saying "I'm going to live a life unaffected by advertising and consumerism." It would be extremely hard. Still, it's a worthy goal to simply listen to yourself and trust your instincts. ✧

Lily, Alice, and Marnie in the Living Room

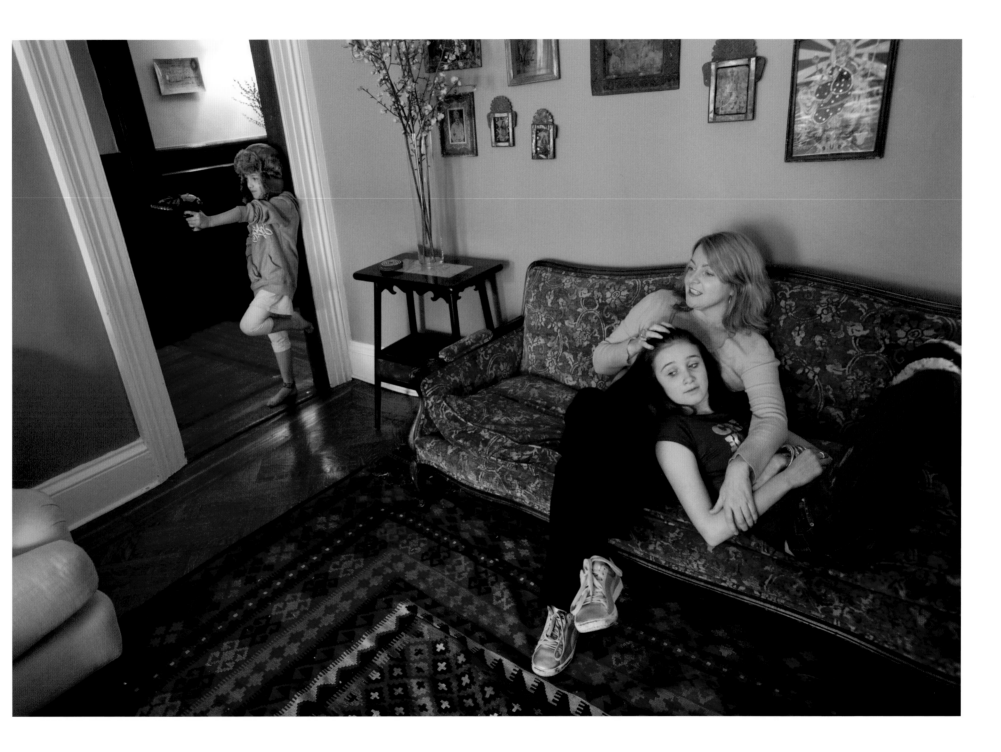

MARY SMITH I DIDN'T REALLY DECIDE TO HAVE A BABY, IT JUST HAPPENED.

I was thirty-two when my daughter was born. I didn't really decide to have a baby, it just happened. I thought I had the flu. When the initial shock wore off, it became a wonderful experience that I sailed through, even at what my family and I thought was an advanced age for childbirth. Things have changed in that regard, thankfully.

My parents were in their late thirties-early forties when I was born and had lived a somewhat unusual life. My sisters are my half-sisters from my mother's two former marriages. My parents had a common-law arrangement, and they both seemed tired and distant as I grew up. My father wouldn't look at me for the first three days of my life because the midwife had apparently promised him he'd be getting a son. I don't remember any warm hugs or I-love-you's as a child. The recognition I got was for being smart, clever, or excelling at school. At one point, I remember I was considered the fattest, smartest little girl in the area.

When I had my daughter, Ali, I'd lived in New York City for about three years, completed a Masters of Education in Adult Nursing at Columbia, was working at St. Luke's Hospital, and was in love with a talented, quirky, sensitive man who had recently graduated from the Juilliard School of Music.

I had worked for eleven years before coming to New York, at a hospital in Boston, and I liked to work, mostly because I found it to be a source of independence and identity. I was proud of my ability to take care of myself. I also expected I would have to work in some way for the rest of my life. I was the first in the family to graduate high school and go on to advanced degrees, and have felt some guilt about getting so much further than the rest of my family in that way.

Having a baby only changed me in the sense that I came to know what was important in life—and that I wasn't the only thing that mattered anymore. Marriage to a musician didn't provide the means for taking care of our little family, so I continued to work full-time once I found reliable childcare. The relationship with my partner suffered between work and raising a child, and within two or three years, I knew that I couldn't rely on someone else to take care of both me and our child. We began to live separate lives and he immersed himself more in his own pursuits.

We separated when Ali was seven, which I thought would be an appropriate age in a child's development to make such a radical change, and divorced some time later.

What I believe I did well was exposing Ali to all the good and creative things that a child might enjoy—movement classes, trips, drawing and ballet classes. What I did less well was handle the separation and divorce in a reassuring way. I never did fully help her understand why we had to leave our home and our family as she knew it. I regret that so much! She was angry and traumatized, but I didn't know how to handle our lives any better at the time. I didn't know much about parenting and still don't, but my heart was always in the right place. ✧

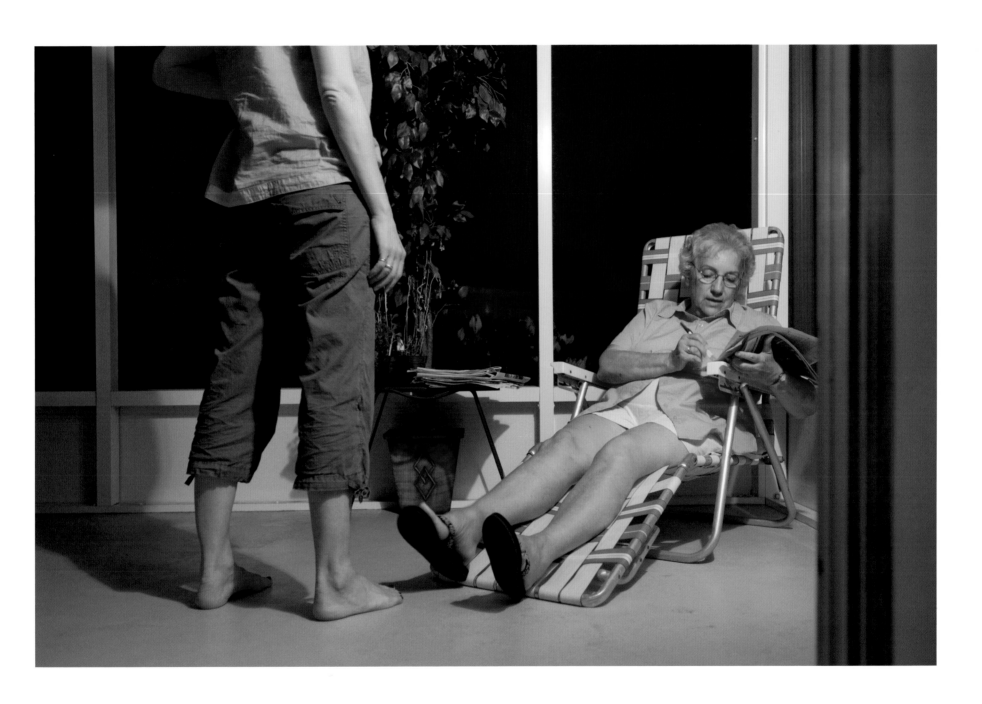

Ali and Mary in Florida

WHAT I WANTED WAS TO PROVIDE ALI WITH THE LOVE AND WARMTH
I HADN'T FELT, EVEN THOUGH IT MAY HAVE BEEN GIVEN. AND TO GIVE
HER THE SENSE OF BELONGING AND OF FEELING WORTHWHILE AND
PROTECTED. I WANTED TO INSTILL INDEPENDENCE IN HER, AND THE
IDEA THAT MANY THINGS ARE POSSIBLE IN ONE'S LIFE. SINCE I DIDN'T
HAVE ROLE MODELS FOR THIS, I MAY HAVE FALLEN SHORT, BUT I TRIED
AS HARD AS I KNEW HOW. I KNOW MY PARENTS DID THE BEST THEY
KNEW HOW TO DO AS WELL.

Mary's Bedroom

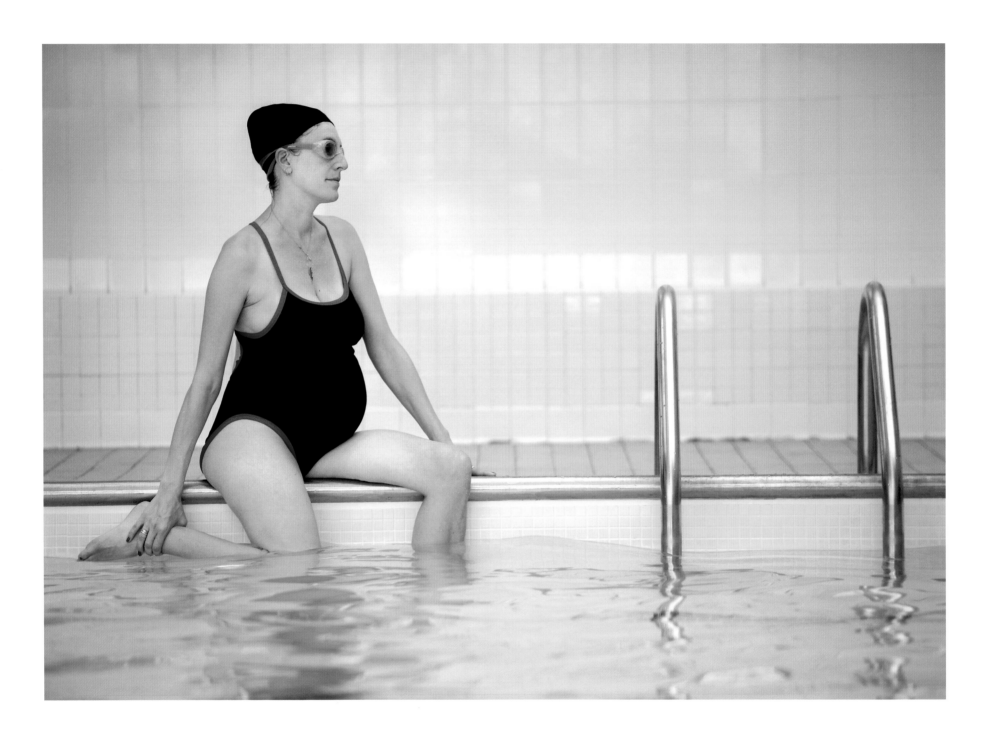

ALI SMITH I RECALL VIVIDLY THE FIRST NIGHT OUR SON, HARPER, SLEPT AT HOME WITH US.

He was all of two days old. He slept right next to us in a tiny hammock thing. The idea that he was now on the outside of my body was so bizarre to me that no matter where he was, I felt myself having to touch something attached to him...a toe, his blanket, something to keep us connected and make me feel that I was still protecting him.

In the middle of that first night, he let out a tiny noise that caused me to bolt upright out of a dead sleep, gasping frantically. My husband didn't stir—but I felt possessed. Radio controlled. Like a voodoo doctor had stuck a pin in me. It was shocking.

Sometimes I miss the earliest days of motherhood. They were insane, of course, but the passing of time creates nostalgia. My son didn't sleep more than three hours at a clip for the first year of his life, which meant neither did I, which kicked my ass. But, in a funny way, it was a very clear time. Much of the outside world dropped away. I wouldn't have felt compelled to keep up with work and socializing even if I'd been able to, physically and mentally. I accepted that my husband and I were in a no-sex period and neither of us felt pressured to change that. We three just existed in this "baby bubble."

I had to feed this baby and keep him alive. Everything else was extra. That simple goal, that animal connection, was freeing for someone who had lived a goal-oriented life; someone who was raised to prize intellect and reason. In that period I had to learn to live day to day.

Naturally, at a certain point the outside world began to encroach again and I felt the strain. While taking care of baby, I'd start to worry that I was disappearing...that my career was done for. When I was out in the world, trying to run the old familiar race, I missed my son like a body misses a limb. Having leaky boobs reminding me of feeding times didn't help. Trying to have significant conversations on three hours of intermittent sleep didn't always go well. The contrast between the two worlds caused a lot of tension for me.

Now that Harper is almost three, the goals of parenting are more muddled. Keeping tethered to him requires thought, mental gymnastics, and reasoning—not just sticking my boob in his mouth or reaching out to hold his toe while he sleeps. Mine is not the only face he sees in focus anymore. Mine is not the only voice he responds to.

Yesterday was a very hard day at the tail end of a difficult week of teething and inexplicable frustration for Harper. Usually a sweet, fun-loving child who is generous with kisses and hugs, he had spent the week as a whining, difficult toddler whom I barely recognized. It brought us both to tears more than once.

Ali at the Pool

On our way home from the park, Harper reached up for me to carry him, which I did. When I scooped him up, the entire weight of him slumped deeply into me. It wasn't the weight of a tiny baby. It was the weight of another human being who desperately needed comfort. And his head—that beautiful head of golden curls, recently cut short for the very first time through a veil of my tears—lay like a heavy melon against my neck. I breathed in the sweet smell of a sweaty boy child who'd been exploring the park for hours. I felt the light touch of his small arms as they encircled my neck, his hands coming to rest on my back. In that moment, I was consumed by a sense of my good fortune and by the awesome nature of my responsibility as his mother. I am the one person in this world who will ever enable him to feel exactly this way.

He'll have friends and lovers and I hope at least one fantastic and true love in his future, and they will all, I pray, provide him with deep understanding and comfort. But this…this. This is a mother's love. The burden and responsibility of being his mother can sometimes over-whelm me, but it never ceases to feel like what it is: a privilege.

Whether I do perfectly well or horribly badly as a parent—or, most likely, something in between—I will remain his one and only chance at feeling he can rely on, be soothed by, be loved unconditionally by his mother. I hope never to be a mother he has to run away from (for more than a little while, anyway). I hope to allow him his own personality, mistakes, and triumphs. And, for my own sake, I hope that I can revisit those early days in the bubble—their simplicity, honesty, animal nature, and completely mind-blowing intensity—within myself from time to time for the rest of my life. ✧

Ali Holds Harper in the Field

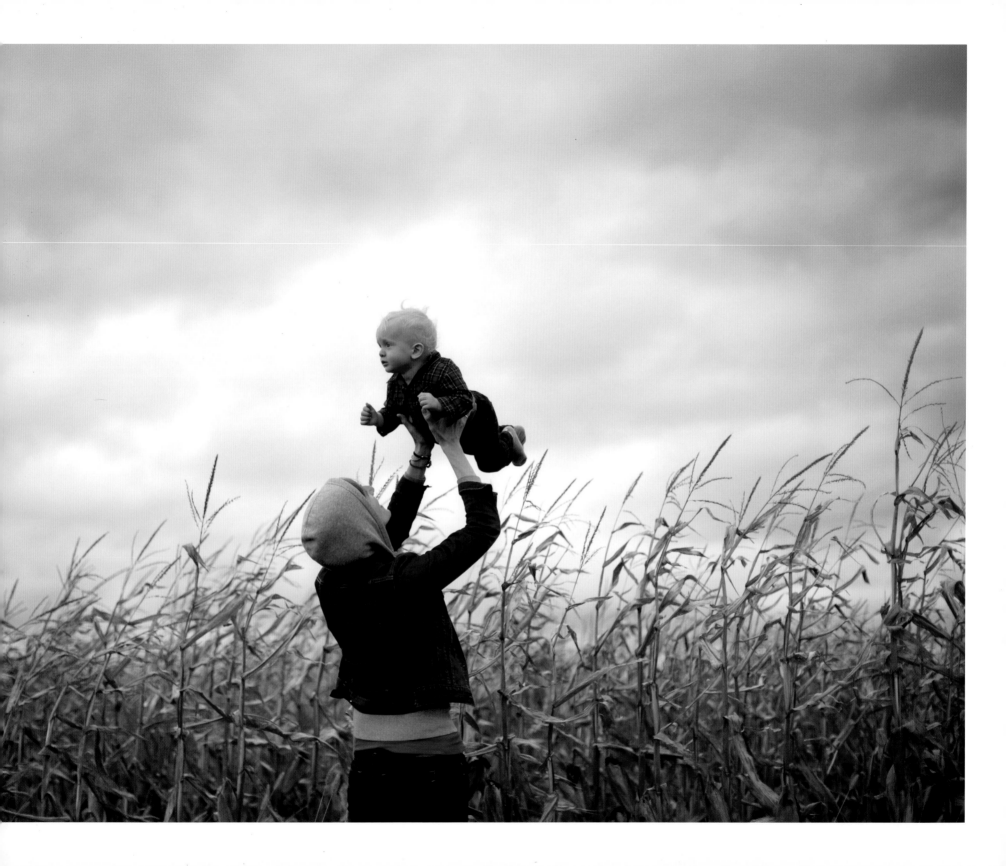

ABOUT THE AUTHOR

ALI SMITH has lived many lives: as a ballet dancer, a recording and touring musician, and a professional photographer and photography teacher. Her first book of photos and original essays, *Laws of the Bandit Queens*, was published in 2002 by *Three Rivers Press* and has been called "this generation's quintessential homage to strong, smart, groundbreaking women." She has been profiled on the *Oxygen* network and in *New York* magazine, was briefly the "face" of *Cosmopolitan* magazine, and has had her work featured and reviewed in numerous publications. She has given readings across the country and shown her work at various institutions including the *International Center of Photography* (*ICP*), *New York University*, and *Alfred University*. She has enjoyed teaching photography to teenage girls on New York's Lower East Side and in the South Bronx, and has volunteered, taking family portraits at a shelter for homeless teenage mothers. A grant from the *Puffin Foundation* enabled her to complete a photo essay on incarcerated mothers in upstate New York, which was published in *Bust* magazine. Ali lives in New York City with her husband and three-year-old son. The common thread throughout her personal work is a passionate interest in the value and quality of the lives of women and girls.

18 MICHELE QUAN is originally from Vancouver, Canada, and moved to New York City in 1984. For twelve years prior to her current work in ceramics, she was a jeweler and cofounded the jewelry company Me & Ro. Michele lives in New York City with her husband, her daughter Elsie Tree, and their dog, Sparrow.

22 ALYSON PALMER is an activist, entertainer, writer, and music director best known for her work as the bass player and vocalist in the band BETTY. Aside from performing live concerts internationally for over twenty-five years, the band has recorded TV theme songs, commercials, and film soundtracks, and has won numerous artistic and humanitarian awards. Alyson lives and breathes for empowering girls and women, chocolate-peanut-butter hybrids, and her beloved children Ruby and Lake (a.k.a. the Ring-Tailed Rascal).

26 HANNAH BRIGHT lives in a small market town in Yorkshire, England, with her daughter Lizzie Rose and husband Ian. She works as a part-time employment judge in Manchester and enjoys picnics in the park, coffee with the other mums, crocheting, real ale on a Monday night, camping and hiking in the beautiful Yorkshire Dales countryside, and exploring mindfulness and meditation.

30 KITTY STILLUFSEN 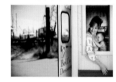 is the daughter of a nurse and a commercial lobster fisherman. Her family owns Red's Lobster Pot in Point Pleasant, New Jersey. Kitty has traveled the world and owns a beautiful property in a very remote part of Costa Rica where she lives off the grid, even in the dead of winter, when she sometimes lives in a tent without electricity. She co-parents her daughter, Olive, with her two gay best friends, Olive's "papa" and "daddy."

32 KELLY STORRS 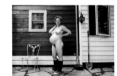 lives with her husband and son in Woodstock, New York, sandwiched between a busy road and a beautiful river, designing gardens and getting dirty.

34 AMY RYAN 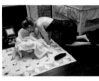 was born in Queens, New York, and is an Oscar- and Tony-nominated actress. She is (so far) best known for her roles in the film *Gone Baby Gone* and as Michael Scott's love interest, Holly, on the hit TV comedy *The Office*. She lives with her husband, a comedy writer, and her daughter, a natural-born comedian, in New York City.

38 BROOKE WILLIAMS' 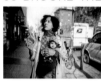 main gig these days is as the mother of four-year-old Ada. In what little spare time she has, she blogs on her own website, thisisauthentic.com, and is the editor-at-large for the blog Krrb.com. Brooke also works as a photographer, writes pieces for various magazines, and plays music under the name The New Black. She has written, performed, and recorded with bands including The Beastie Boys, Sybarite, The Lemonheads, and Speedball Baby.

42 BRENDA DAVIS is a single mother of a strong, political, independent daughter. She is also a filmmaker, writer, and film researcher. She recently completed her first feature documentary, called *Sister*, an intimate portrait of the global crisis of maternal and newborn mortality.

44 MELANIE WADSWORTH is a fine artist and illustrator who shares custody of her son Lionel with her ex-husband. She has been a recovering addict for over fifteen years, suffers from bipolar disorder and PTSD, and takes the "one day at a time" motto seriously. She will gladly tell you that becoming a mother was one of the best decisions she's ever made.

48 RASHIDA TAHERALY is the mother of two daughters and one son. She is an Indian Muslim born in the United Kingdom, now living in America. Rashida has traveled throughout Europe, India, East and North Africa, the Arab countries, the Far East, and Australia. She currently helps manage the family business, a hardware and garden shop. She and her family are deeply dedicated to their faith, community, self-exploration, and creativity.

52 ERIKA KIRKLAND is a professional clown and mother of a very

artistic teenage daughter, Brittainy. Although her boyfriend has been a good and supportive partner for many years, Erika raised Brittainy as a single mother on the Lower East Side of Manhattan. She founded a children's entertainment company called Best Clowns and has supported her family for years as Giggles the Clown.

56 ALICIA MIKLES was born in Syracuse, New York. She has been an

award-winning art director and graphic designer for over eighteen years and recently launched her own design studio. Her artwork has been exhibited in many venues and galleries, and has been sold to private collections. She is also a performance artist and works as a yoga instructor. Alicia lives in the Hudson Valley with her husband, son, and daughter.

60 NGODUP YANGZOM is the oldest of four children. She is a Tibetan

born in the village of Bhandara in Maharashtra State, India. She works as a nanny and lives with her husband, a cab driver, and their five-year-old daughter in Queens, New York.

64 DIANA JOY COLBERT was a massage therapist, Ph.D. candidate in

English, and English professor. When her daughter, Lily Starr Colbert Bock, was six months old, Diana was diagnosed with acute myelogenous leukemia. Despite enduring two bone-marrow transplants and countless other treatments daily over the course of the next two-and-a-half years, Diana managed to fill her daughter Lily's life with as much love as any mother could impart. She passed away on December 8, 2011, three days before Lily's third birthday.

68 KAREN DUFFY rose to fame first as a model and then as MTV VJ

"Duff" in the early '90s. She has appeared in such films as *Dumb and Dumber* and *The Fantastic Mr. Fox*. At its height, her professional career was sidelined by a chronic illness which she has dealt with using her trademark humor. She's authored several books, including her autobiography, *Model Patient: My Life As an Incurable Wise-Ass*. She lives with her husband and son, "Lefty."

72 JEN FUGLESTAD a southern girl until she was twenty-nine, made
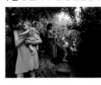
the move to New York City in 2000, in time to celebrate her thirtieth birthday. After spending six years in the land of television commercial production and meeting her kickass husband, she left her job to raise her three gorgeous girls, Bella, Lucia, and Emerson.

73 LINDSEY BLISS is a birth doula, devoted wife, and mother to six

kids (five biological plus one stepdaughter). She prides herself on being a multiples expert after giving birth to two sets of twins. Lindsey holds a Bachelors Degree in Fine Arts, volunteers as a community activist working to end sexual violence, and loves practicing yoga.

76 LAUREN RIDLOFF is a teacher and sign model turned stay-at-home

momma. Originally from Chicago, she spent a few years in California and now lives in Brooklyn with her husband and their baby son, Levi.

80 TRAE BODGE NAPIERALA is a beauty entrepreneur-turned-life-
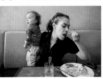
style writer and a broadcast media spokesperson. She and her husband Chris, a mitigation expert, both work from their Montclair, New Jersey home, where they live with their daughter, Sadie Mae.

84 LYNDA COHEN KINNE graduated with a degree in photography
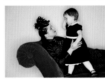
from Parsons before reenrolling to study fashion. She and her husband are the founders of the avant garde fashion label A la Disposition. Their work has been included in several books on fashion and is in the permanent collection of the Museum at the Fashion Institute of Technology.

86 AMY RICHARDS is the author of *Opting In: How to Have a Child* 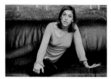 *Without Losing Yourself* and the co-author, with Jennifer Baumgardner, of *Manifesta: Young Women, Feminism and the Future*. Amy is a founder of the Third Wave Foundation and Soapbox, Inc., and her writings have appeared in *The Nation*, *The Los Angeles Times*, *Bust*, *Ms.*, and numerous anthologies. She was a consulting producer of HBO's Gloria Steinem documentary, *Gloria: In Her Own Words*, and lives with her husband and two sons.

88 TERRY BORN was born in a displaced persons camp, the only 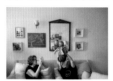 child of a Holocaust survivor and a soldier of the Russian Army. She started a career in education as a middle-school teacher and became founding principal of one of the first small public high schools in New York City. Since her retirement, she has been a coach, helping to start small schools throughout the country. Her child, Jey (formerly Jennica), was born in 1977 and is now married and the proud father of Lusa. Terry is also a painter and spends as much time as possible hiking, traveling, and relaxing with her husband Peter on the Greek island of Hydra.

92 ERICA LYON has been a pregnancy-and-parent educator for sev- 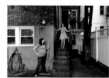 enteen years. She was the Founder and Director of Realbirth, New York City's first comprehensive independent childbirth and postpartum education center. She currently consults as an education director for various prominent birth and parenting centers, and has just launched www.Birth360.com, bringing her teaching to a free online video format. She is the author of *The Big Book of Birth* and a mother of three.

96 PATRINA FELTS was born and raised in Jersey City, New Jersey. 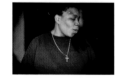 The second of three children, she has been a foster mom to many and is the single adoptive mom of four. Patrina takes great pleasure in helping children and hopes to adopt more. Currently, she works in accounting.

100 DEB PARKER became the mother of her fabulous boy named 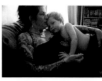 Earl at the ripe old age of forty-five. "I wasn't planning or expecting to get pregnant," she says. "Ironically, and unintentionally, Earl's initials stand for Early Pregnancy Test as well as Earl Parker Thomasson." She has been a bar owner and an entrepreneur, but says that having a child has been her biggest and best adventure.

102 LUANN BILLETT has taught photography at an all-girls boarding 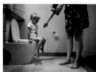 school in Lititz, Pennsylvania, for fifteen years. She is currently writing a memoir about her experiences as a widow and single mother of triplets, while finishing her Masters Degree in Counseling Psychology. She recently remarried.

106 SHANNON O'KELLY WHITE is the mother of two and works as 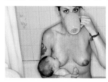 a hairdresser in New Jersey. She has hosted and produced a live Internet TV show on which she interviewed bands, sex-industry workers, and feminists. Shannon believes in the importance of being honest about pregnancy, childbirth, sex after childbirth, and post-baby marriage. She feels strongly that this openness allows others to share their own fears, shame, horror, joy, guilt, and anxieties.

108 DEBORAH COPAKEN KOGAN is a former award-winning war photographer and Emmy-Award-winning TV news producer. Currently a novelist, she is the author of four books: the *New York Times* bestseller *The Red Book*; the *Elle* Readers Prize-winning *Between Here and April*; the bestselling memoir of her years as a photojournalist, *Shutterbabe*; and *Hell Is Other Parents*, a collection of humorous essays that she subsequently adapted for the New York stage. She lives with her husband and three children in Harlem, New York.

112 SOPHIE CURRIER was a medical student whose landmark law- 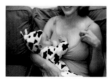 suit over her right for adequate time to breastfeed during her medical board exam went all the way to the Supreme Court, where she prevailed and made history. Sophie recently moved from Boston to rural England with her husband and two children.

116 ERIKA DEVRIES is a mother, artist, lady in love, professor, fairytale teller/reader/believer, thread thief, and mundanity expert. She is step-familying her children with her beloved and their bees, and is grateful to be widening her circle of love. You can view her work online at www.ErikasWonderlands.net.

118 CATHERINE GAYNOR is the proud stay-at-home mother of Sophia and her younger brother Jackson, and is married to a Local 638 steamfitter. Catherine and her husband Vincent started the Sophia's Cure Foundation (SCF) in May 2009, shortly after their daughter was diagnosed with SMA (Spinal Muscular Atrophy). Through that organization, they have raised over two million dollars in three years for research into the disease. Catherine is dedicated to ending SMA and spending every second creating memories and adventures with her family.

122 OLA AKINMOWO is a radical mom, artist, and yoga teacher. She is also an urban gardener who lives to take part in and lead community-based, earth-friendly activities. She works as a set designer and scenic artist for films, television, and commercials, and lives joyfully with her sweet daughter in the village of Brooklyn, New York.

126 WENDY KAGAN is raising her two daughters amid the forests, streams, and fields of Woodstock, New York. She is a freelance writer, a yoga teacher, and the health and wellness editor at Chronogram, a Hudson Valley regional magazine.

130 MAGGIE CRAWFORD is a childbirth educator, doula, Reiki practitioner and Waldorf early childhood educator. She and her partner, Jimmy, have three exceptionally capable daughters.

132 CHRISTINE VARGO is a licensed social worker who has provided counseling services to survivors of sexual and domestic violence for over a decade. Along with being a mother, Chris's proudest accomplishment is riding her bicycle across the United States to raise money and awareness for rape crisis and domestic violence programs.

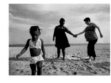

132 JACLYN VARGO has, since the age of four, been involved in U.S. Figure Skating. After competing on the local and national levels over the span of fourteen years, she earned a national appointment to serve as a judge qualified to select the World and Olympic teams. Trained as an attorney, she has served as a prosecutor and is currently working in career services for a law school in New York City. She relishes the role of mother and enjoys creating clever lyrics for existing and sometimes original songs to sing to her children.

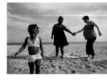

136 TANYA FLY grew up in Battle Creek, Michigan. Formerly a singer-songwriter, she is the founder of a health and wellness company called the NU Method, and the single mother of two boys.

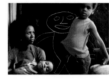

138 ALICE SHIRES is a clinical psychologist based at the University of New South Wales. She is currently working on a Ph.D. that explores mindfulness and its integration into cognitive and behavioral therapies. Alice is the mother of two daughters. For the first three years of her oldest daughter's life, she lived in London as a single working parent. Currently she and her daughters live with her partner in Sydney, Australia.

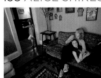

140 MARY SMITH was born in Massachusetts, and raised her daughter (the author of this book) in New York City. If you ask her, she'll tell you that her daughter is "wonderful and creative." Mary worked full time as a registered nurse and instructor of nursing from the time she graduated until her retirement. She is extremely proud to be featured in *Momma Love*.

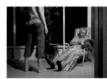

My deeply felt thanks go the following: To my mother, MARY SMITH, without whom, quite literally, none of this could have happened. Besides the small feat of giving birth to me, I credit you with instilling in me a sense that anything is possible. I can now say to you, with great humility and clarity, "I get it!" and "Thank you for everything." To my dear son, HARPER EDWIN DOMINGOS BRIGHTSMITH, by whom I am awestruck and who I love beyond measure, and to SOLVEIG ANNA VALBORG ALMAAS, who first taught me how to be a mother. I'm eternally fighting for you, I love you, and I have utter faith in you both. To my soul mate and husband, JOSHUA BRIGHT. You have bolstered me with your endless support and invaluable and honest feedback. Your life is a beautiful, shining example of a man's potential to be a devoted, brilliant, involved, fair-minded, and loving father, husband, and artist. You are an aspiration. To my agent, MISS JILL GRINBERG, who "midwifed" me for many years through the process of giving birth to this book. Your courageousness, sensitivity, and tireless dedication have been crucial in shaping this work and I am eternally grateful. To my "mom gang," the ladies with whom I entered into motherhood screaming, crying, and laughing maniacally; AMY RYAN, ANNIE PARISSE, MIRIAM SHOR, JULIE PEACOCK, and PATTY JEN ARNDT. You've offered humor, support, and a shoulder to sob on, each in the right amount and at the perfect time. To the people who helped shape this book in form and content: JANET STEEN, LAURA ROSS, AMY ARBUS, JEN MCCLURE, JESSICA SHYBA, PAMELA MATSUDA-DUNN, LARRY DUNN, LINDA BRIGHT, JON HOWARD, KARIN PAPROCKI, ALISON WEAVER, LIZZY BROMLEY, MEGHAN MCDERMOTT, DONNA FERRATO, and LILY WOLF. To the life and memory of DIANA COLBERT, a woman who taught me a lot in a little bit of time. And finally, my profound gratitude and respect goes to ALL OF THE FASCINATING WOMEN FOUND ON THESE PAGES—beacons of light, every one. Your openness, generosity, wisdom, vulnerability, and heartfelt sharing pave the way for new understanding. You are revolutionary and I feel forever bonded with you. Viva la revolución. And much momma love to you all.

Published by Thunder Baby Press

30 Waterside Plaza Suite 26K, New York, NY 10010

Manufactured in the USA. This book was printed by a Printing

Industry of Minnesota Green Printer. SHAPCO Printing is a

Forest Stewardship Council (FSC) certified printer using

Agri – based inks. SHAPCO recycles in compliance with PIM

environmental initiative (make-ready and paper waste at

100%, aluminum plates, pallets and all packing materials are

all recycled).

The Avery Group at shapco.com/theaverygroup

ISBN 978-0-9887551-0-9

Library of Congress Catalog Card No. 2012955641

9 8 7 6 5 4 3 2 1

Cover and interior design by Ali Smith

All photographs © Ali Smith

www.alismith.com

www.alismith.com/blog/category/momma-love/

www.facebook.com/MommaLoveTheBook

www.MommaLoveTheBook.com

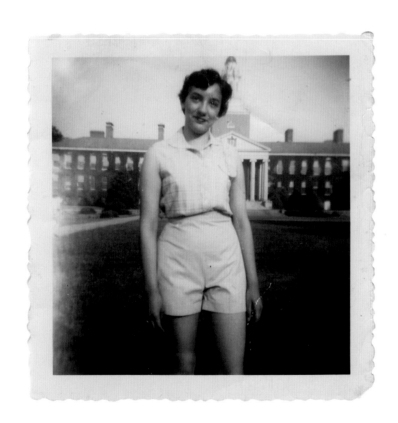